This book is dedicated to those

who spread the character's majesty and good cheer

through acts of kindness towards others.

Wondrous Mrs. Claus

A Literary & Pictorial Review
of the Christmas Character

Written and Curated by
Pamela McColl

Grafton and Scratch Publishers

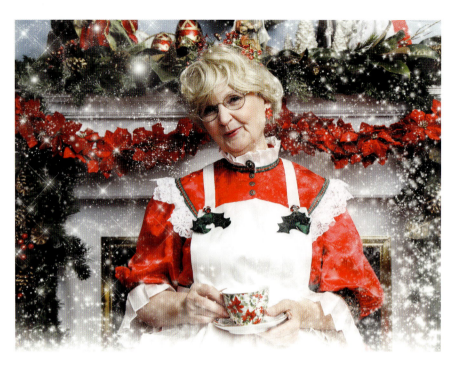

Credit: *Deborah Grose: Forever the Christmas Optimist, Mrs. S. Claus.*

"MRS. KRISS KRINGLE"
by Edith M. Thomas, 1885.

OH, I laugh to hear what grown folk
Tell the young folk of Kriss Kringle,
In the Northland, where unknown folk
Love to feel the frost-wind tingle.

Yes, I laugh to hear the grown folk
Tell you young folk how Kriss Kringle
Travels 'round the world like lone folk,
None to talk with – always single!

Would a grim and grave old fellow
(Not a chick nor child to care for)
Keep a heart so warm and mellow
That all children he'd prepare for?
Do you think, my little maiden,
He could ever guess your wishes –
That you'd find your stocking laden
With a doll and set of dishes?

No; the truth is, some one whispers
In the ear he hears the best with,
What to suit the youngest lispers,
Boys and girls, and all the rest with.

Some one (ah, you guess in vain, dear!)
Nestled close by old Kriss Kringle,
Laughs to see the prancing reindeer,
Laughs to hear the sledge bells jingle.

Dear old lady, small and rosy!
In the nipping, Christmas weather,
Nestled close, so warm and cozy,
These two chat, for hours together.

So, if I were in your places,
Rob and Hal, and Kate, and Mary,
I would be in the good graces
Of this lovely, shy old fairy.

Still I laugh to hear the grown folk
Tell you young folk how Kriss Kringle,
Travels 'round the world, like lone folk,
None to talk with – always single!

CONTENTS

	Introduction	4
CHAPTER 1	Setting the Stage	6
CHAPTER 2	The Literature	24
CHAPTER 3	Music, Theatre and Film	76
CHAPTER 4	Meeting Mrs. Claus	84
CHAPTER 5	Collecting Mrs. Claus	89
	Conclusion: A Heroine for the Ages	91
	Credits	94
	Index of Authors	95
	Author's Page	96

INTRODUCTION

Mrs. Claus made her debut on the written page in 1849. Over the past two centuries, as this literary and pictorial review discovered, the Christmas character was continually reimagined for juvenile and adult works of fiction, in poetry, lyrics and for musical, theatrical and film productions.

This publication is the first to extensively chronicle Mrs. Claus, as presented and published through the years.

Mrs. Claus, the wife and partner to the global superstar Santa Claus, needs little introduction. Her kindness and charm are legendary.

The character is also an enigma. Instead of being defined by a single seminal work, Mrs. Claus has undergone numerous reinventions, with her character continuously adapted to align with the sentiment and nature of each respective era.

She has been described as a fairy, an elf, a saint, a spirit, a redhead, brunette and blonde, portrayed as a girl, young woman, a wife, mother and a grandmother of old. Through all her various incarnations she has evolved as the premier heroine of Christmas literature, her character a vibrant role model for modern times.

As a kindred spirit to her benevolent and most merry husband, "The First Lady of Christmas" embodies living with the essence of Christmas in one's heart.

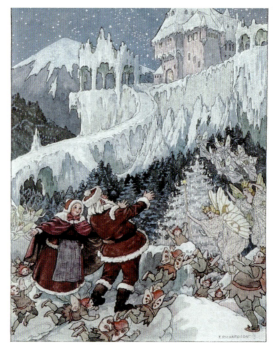

Who reads the notes from girls and boys?
Turns in the order for their toys
Fills every heart with wondrous joys
Mrs. Santa Claus.
 "Mrs. Santa Claus" - 1953

Credit: P.94

"She was a very pretty little girl with very long red hair that she preferred to wear in a long plait to the side."
The Untold Story of Mrs. Claus
by Adam Greenwood.

"For she was a lady tall and fair,
With a quiet smile and a loving air."
"Mrs. Santa Claus' Present"
by Alice S. Morris.

"Oh Mrs. Santa Claus was a very sensible old lady; you may be sure. A soft lacey collar and white cap, and the mountain dwarfs gave her gold-rimmed spectacles to help her as she did her sewing."
The Story Lady's Christmas Stories
by Georgene Faulkner.

Credit: *London Illustrated News*, December 20, 1862.

CHAPTER ONE – SETTING THE STAGE

"It was a lady, but she seemed as from some other sphere. Her mantle all embroidered o'er with glist'ning flakes of snow; Her hair like sparkling strings of pearls or dew-drops seemed to grow."
"Mrs. Santa Claus and Jessie Brown."

Mr. and Mrs. Claus are American creations of the first half of the nineteenth century.

Their lineage is a rich and colorful pageantry of characters and figures of the ecclesiastical and secular realms, who have graced mid-winter celebrations, and the observance of Christmas over the length and breadth of Western culture. The ancient gods, goddesses, saints and angels, along with a host of other-worldly magical beings set the stage for the development of the Claus characters and the creation of their enchanting story.

Credit: *Mrs. Santa Claus and Jessie Brown, Harper's Weekly,* January 9, 1869.

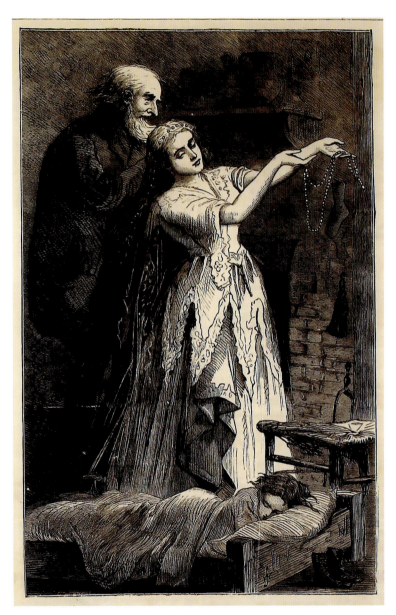

Ancient cultures of the Northern Hemisphere acknowledged the Winter Solstice, as a time of diminished daylight and the longest night of the year. Celebrations were held to honor the deities associated with agriculture, prosperity, fertility and the sun.

The Roman festival of Sol Invictus, held on December 25, honored Sol, the Sun God. Saturnalia, a multi-day festival that honored Saturn, the God of Agriculture and Time, included entertainment, feasting, gift giving and decorating with greenery. These events were held during winter, a season often associated with the risk of scarcity and difficulty, when apprehension and concern were prevalent. Supernatural beings, including malicious ones, were believed to be most active during this time of the year.

Credit: *Central design of moon goddess rising stag-drawn chariot across the sky* by Michel Angelo Pergolesi, 1777-1784.

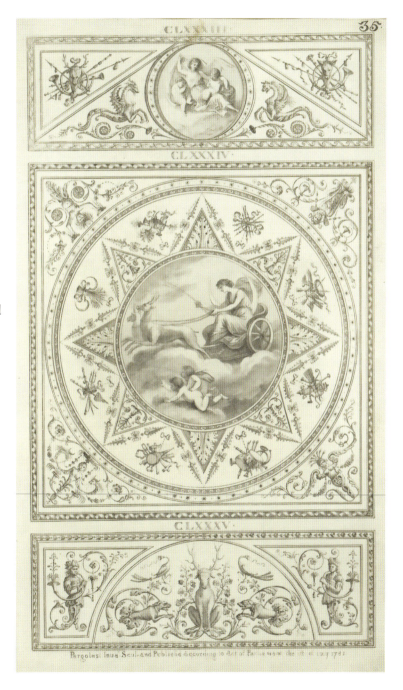

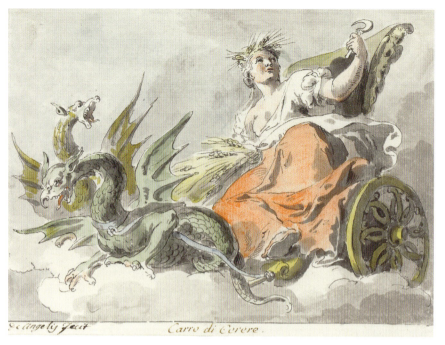

Goddesses are central figures in ancient Greek and Roman mythology. Stories tell of their heroic deeds performed on their own or in partnership with male counterparts. The deities provided guidance, imparted wisdom, and offered protection to individuals who had faith in their mystical abilities.

The festival of Brumalia, observed in both Greek and Roman cultures, spanned from mid-November to the Winter Solstice. During Brumalia, animals were sacrificed to the deities, with gifts bestowed on priests in honor of the Greek Goddess Demeter, and the Roman Goddess Ceres, both goddesses of agriculture and fertility of the land.

Angerona was the Roman Goddess of Winter Solstice. Angeronalia, also referred to as Divalia, was a festival celebrated during the Winter Solstice in honor of the deity. She represented strength, with the ability to relieve anguish and fear. Angerona was believed to facilitate the sun's resurgence at midwinter.

Credit: *Carro di Cerere (Chariot of Ceres)* by Pietro de Angelis, 1825.
The Goddess Protection by Sidney Ashmore, 1872.

December 25 was established as the official date of Christ's birth by Roman Emperor Constantine I in AD 336. Around AD 221, Julius Africanus authored the first Christian chronology, titled *Chronographiae,* in which he asserted that March 25 was the date of Jesus' conception, a date nine months before Christmas.

Credit: *Three Goddesses*
by Walter Crane, 1870s.
Song of the Angels
by William Adolphe Bouguereau, 1881.

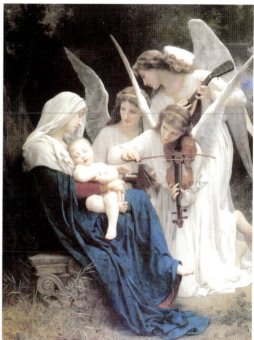

The ancient Germanic, Celt, and Norse peoples called the Winter Solstice Yule or Juul. The multi-day event featured pagan rituals, feasting, and revelry. The ancient Druids practiced burning a log to initiate the celebrations. In Celtic mythology, the Yule log symbolised the Cailleach, the Old Woman of Winter and creator of storms. A log carved in her likeness was burned at Yule to banish the cold and dark. Beira, the Queen of Winter, was a name given in the twentieth century to the character. The Sami people of Northern Scandinavia revered the Deer Mother, regarding her as the guardian of the sun.

It was believed that during Yule, the Deer Mother traversed the skies, delivering the sun and heralding the advent of new life to the land. The female character Saule rode the skies in a reindeer-pulled sleigh. Mother's Night, or Modraniht, observed on Yuletide Eve, was dedicated to venerating the wisdom and fertility of ancestral mothers.

Credit: P.94

According to ancient Germanic and Northern European folklore, during the Winter Solstice, the God Odin and his wife, the Goddess Frigg, were believed to traverse the skies in pursuit of spirits from the underworld. Odin and Frigg rode Sleipnir, an eight-legged horse, delivering gifts and good tidings to the worthy.

Snegurochka, the Snow Girl, traveled with Ded Moroz, the Slavic Winter Wizard.

The Icelandic Gryla and a phantom in white, named Perchta or Bertha, pursued those who misbehaved.

A female character named Lussi was believed to descend chimneys on December 13, coming to snatch children.

Credit: *The Christmas Coach* by Raymond Crawford Ewer, 1914.

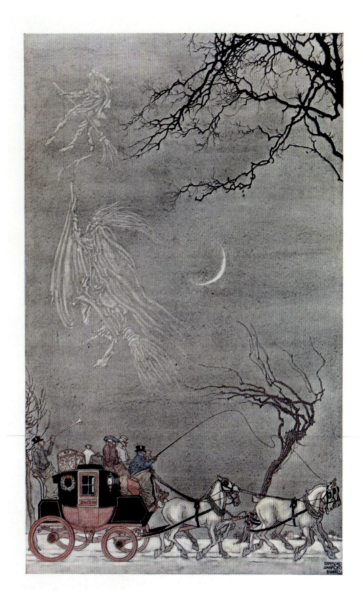

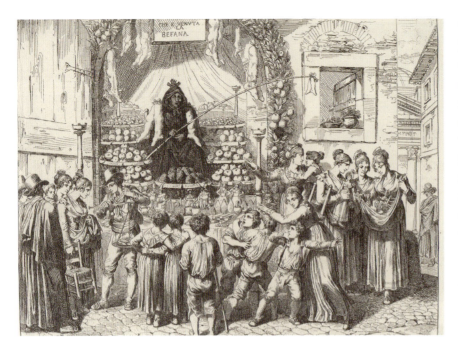

Credit: *La Befana*
by Bartolomeo Penilli, 1821.
Virgin with Child Crowned by Angels
by Colijn de Coter, 15c.

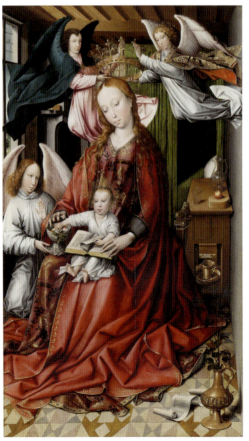

The tale of the folklore figure, La Befana also known as the Italian Christmas Witch, combines elements of secular legend with religious teachings. The Magi, on their journey to Bethlehem to visit the Christ child, stop at the residence of La Befana. She does not accompany the Maji as she has much sweeping to do. Regretting her decision, she embarks on a journey to find the baby Jesus. On January 5th, the eve of the Epiphany, La Befana is believed to ride a broom through the skies, and to descend chimneys delivering sweets to the deserving and coal to the naughty. In the Christian calendar, the Epiphany or Feast of the Three Kings, signifies the arrival of the Magi in Jerusalem.

The notion of witches descending chimneys was examined in *Malleus Maleficarum,* by Heinrich Kramer in 1486. Witches have been part of folklore for centuries, often practiced in secret with the Christian church's prohibition of witchcraft, as noted in the Canon Episcopi of AD 900.

Babouscka, also known as Babushka, is a character from old Eastern European folklore. She is depicted as an elderly woman who carries a cane and a basket of toys. Children anticipate her arrival on Christmas Eve with the expectation of receiving gifts. The story *Babouscka: A Russian Christmas Story,* an English retelling of the legend by Adelaide Skeel Kelly, was published in the January 1882 issue of *Wide Awake*.

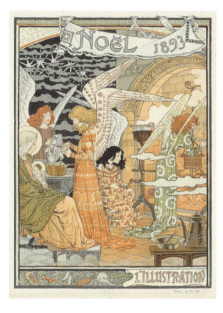

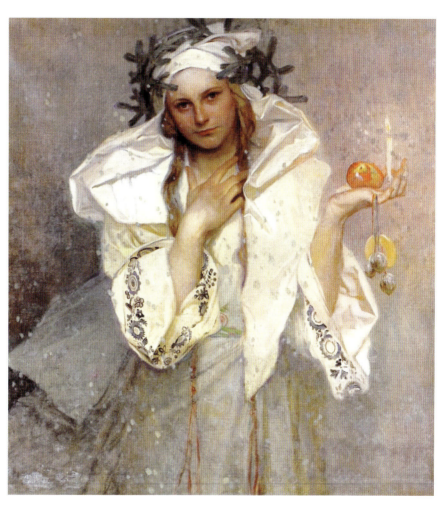

St. Lucy's Day of December 13 was initiated in the fourth century to honor the martyred Saint Lucia of Syracuse. The event remains popular, particularly in Scandinavian countries. St. Lucy's Day processions are led by young women dressed in white gowns with red sashes, adorned with candlelit wreaths on their heads. Boys in white gowns with pointed hats or dressed as gingerbread men join in. St. Lucy distributes gifts to some individuals and coal to others. Lindsborg, Kansas and Hutto, Texas host well-attended St. Lucy Day events in America.

Credit: *Christmas in America* by Alphonse Mucha, 1919. *Noel,* 1893

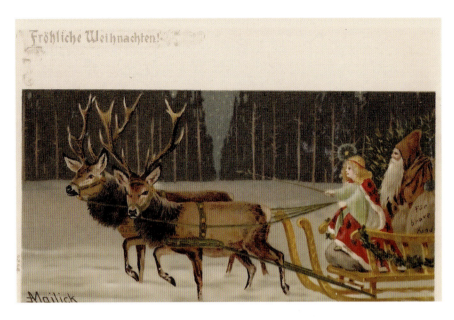

In the early 1500s, German Protestant Reformers banned praying to saints and removed saints' days from the church calendar. During the Reformation, a figure named Christkindl appeared associated with Christ. The Christkindl delivered gifts to children on Christmas Eve, keeping December 25 as a holy day. The Christkindl is traditionally portrayed as a young girl or woman with blonde hair, dressed in white or gold attire, and adorned with angel wings.

Credit: *Fröhliche Weihnachten! (Merry Christmas)* by A. M. Mailick, 1890-1910. *Christkind* by Stadt Gottes, 1893.

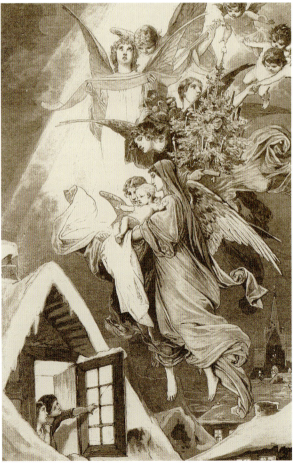

By 1572, Yuletide had become synonymous with Christmas in Great Britain. A character named Yule appeared alongside a female performer named Old Bet, Old Betty, and Dame Dorothy during the Twelve Days of Christmas. Accounts mention a Mother Christmas character, who performed with a bearded and cloaked representation of Christmas, known as Father Christmas.

In 1647, the British parliament prohibited both public and private celebrations of Christmas, Easter, and Pentecost. The ban was lifted in 1660. In 1659, the Massachusetts Bay Colony enacted a law known as the *Penalty for Keeping Christmas,* which was repealed in 1681. On June 28, 1870, Thanksgiving, Christmas Day, New Year's Day and July 4th were designated federal holidays in the United States.

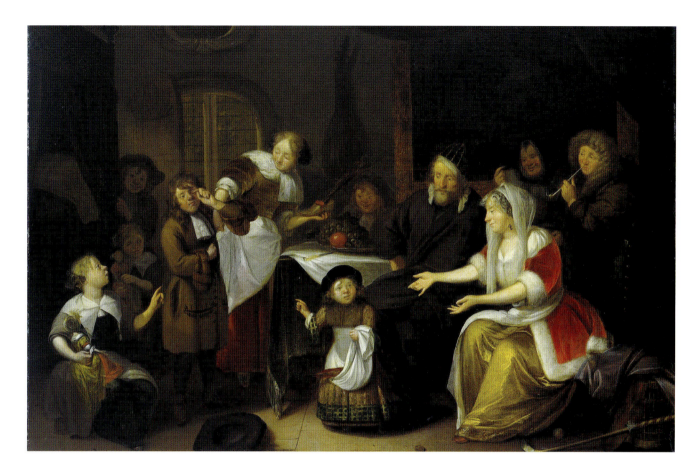

Saint Nicholas, a Christian bishop of the fourth century of ancient Patara, Asia Minor, is revered as the Patron Saint of Children. The legends of St. Nicholas' miraculous acts and generosity are integral to the Claus characters and the story of Santa's arrival on Christmas Eve.

St. Nicholas is referenced in literature as on his own, with a companion, and on occasion with his wife. *The Book of St. Nicholas, A Legend of St. Nicholas* written in 1831 by James Kirke Paulding, reads: "He is a right fat, jolly, roistering little fellow…. Everybody has heard of St. Nicholas, that honest Dutch saint, whom I look upon as having been one of the most liberal, good-natured little fat fellows in the world….But as soon as the worthy Nicholas arrived at the age of twenty-four, being, as I said, within a year of the expiration of his time, he thought to himself that Katrinchee, or Catharine, as the English call it, was a clever, notable little soul, and eminently calculated to make him a good wife." Paulding writes that Catherine and St. Nicholas of Amsterdam were bakers.

1880: *A Glimpse of An Old Dutch Town, Harper's Monthly,* December 1879: "Christmas was of little importance among the Dutch, for New-Year was the day, and then it was that the right fat, jolly, little St. Nicholas made his appearance, sometimes accompanied by his good-natured vow (wife) Molly Grietje."

1879: Mrs. W. J. Hay wrote in *Buster's Christmas Present, Harper's Young People,* December of St. Nicholas stating: "Ho, there, Merry thought! Send for Mrs. Christmas, my housekeeper."

Credit: *Feast of St. Nicholas* by R. Brakenburg, 1685.

1773: The Saint's death date of December 6th has long been recognized as St. Nicholas Day. The earliest recorded reference to St. Nicholas Day in America was reported in *The New York Gazette:* "Last Monday (i.e., 13 December) the Anniversary of St. Nicholas, otherwise called St. A. Claus, was celebrated at Protestant-Hall, at Mr. Waldron's, where a great number of sons of that ancient Saint celebrated the day with great joy and festivity." (Note: A deviation in the date.)

1809: The legendary St. Nicholas was further popularized, both in America and abroad, by Washington Irving. St. Nicholas is referenced twenty-five times in Irving's *A History of New York, from the Beginning of the World to the End of the Dutch Dynasty,* published on St. Nicholas Day. "Occasionally pulling presents from his pockets and dropping them down chimneys", "laying a finger beside his nose", "flying in a wagon", wrote Irving of his St. Nicholas of Manhattan, NY.

1821: "A New-Year's Present, to the Little Ones from Five to Twelve, *The Children's Friend,*" 'Old Santeclaus' arrives on Christmas Eve riding a reindeer led cart, dressed as a bishop. He brings books to children and carries a dreaded birchen rod.

1822: James Fenimore Cooper in his novel *The Pioneers* wrote: "Aggy! Remember, that there will be a visit from Santa Claus to-night." This is the first time the name Santa Claus appears in print.

2022: A relic of Saint Nicholas resides in the St. Nicholas Greek Orthodox Church and National Shrine, in New York, NY.

Credit: *The Children's Friend,* William B. Gilley Publisher, New York, NY, 1821.

1822: Clement C. Moore's "An Account of a Visit from St. Nicholas", (Twas the Night Before Christmas), introduced St. Nicholas as a jolly elf named St. Nick. Moore's description of St. Nick delineated the character in the hearts and minds of readers for generations to come.

Down the chimney St. Nicholas
came with a bound.
He was dress'd all in fur,
from his head to his foot,
And his clothes were all tarnish'd
with ashes and soot;
A bundle of toys he had flung on his back,
And he looked like a peddler
just opening his pack.
His eyes – how they twinkled!
His dimples how merry!
His cheeks were like roses,
his nose like a cherry!
His droll little mouth was
drawn up like a bow,
And the beard of his chin
was as white as the snow…

He had a broad face
and a little round belly,
That shook when he laugh'd,
like a bowl full of jelly.
He was chubby and plump,
a right jolly old elf….

Over the last two centuries, artists and illustrators have made modifications to the St. Nick character described by Moore, most notably enlarging the elf's stature. Aside from these visual alterations, Moore's description continues to serve as the definitive representation of Santa Claus. Mrs. Claus, in comparison to her husband, emerges through multiple stories and poems, resulting in a less well-defined character, who is subject to greater artistic license by both authors and artists.

Credit: *Merry Old Santa Claus* by Thomas Nast, 1881.

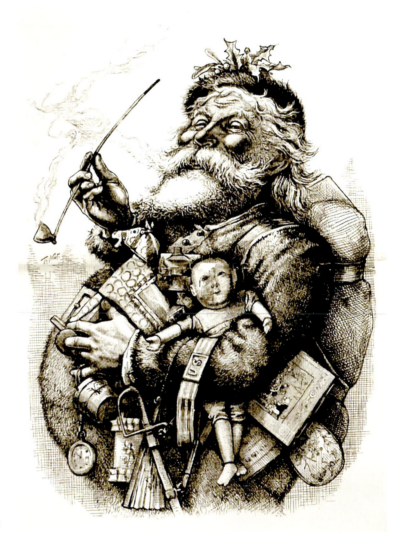

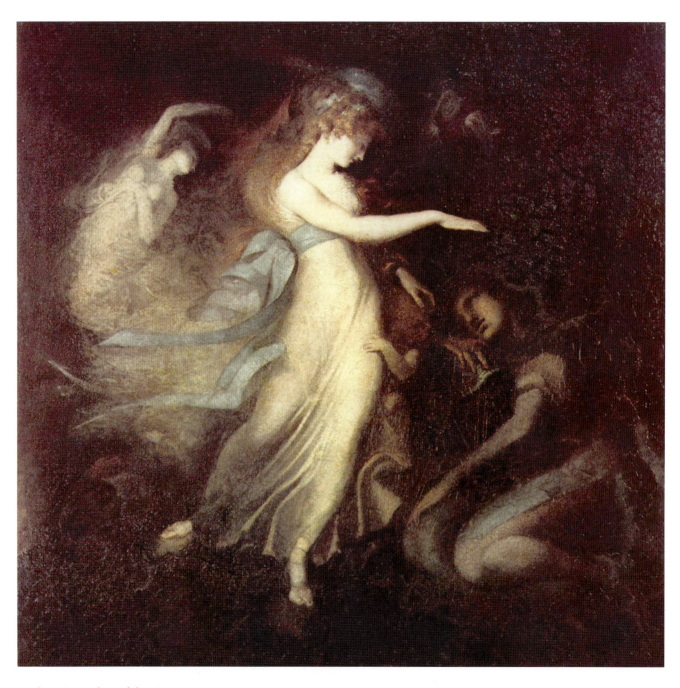

Credit: *Prince Arthur and the Fairy Queen* by Johann Heinrich Fussli, 1788.

The nineteenth century brought a renewed interest in ancient mythology and folktales of the supernatural.

The British writers Ben Jonson, Robert Herrick, John Milton, and William Drayton wrote of Queen Mab, The Queen of the Fairies, as did William Shakespeare in *Romeo and Juliet*.

1812: Jacob and Wilhem Grimms released their first collection of fairy tales.

1813: Percy Bysshe Shelley's first major poem, "Queen Mab" (1813), is of a past, present and future scenario. The New York Public Library holds an edition of the poem previously owned by Charles Dickens.

1819: Washington Irving drew inspiration from Celtic and Germanic folktales for his mystical short stories, "Rip Van Winkle" and "The Legend of Sleepy Hollow" (1820).

1836: Charles Dickens involved fairies, ghosts, and goblins in many of his works: *The Story of the Goblins Who Stole a Sexton, A Christmas Story,* a gravedigger is kidnapped by goblins, *A Christmas Carol, In Prose Being a Ghost Story for Christmas* (1843) three ghosts appear, *The Cricket on the Hearth: A Fairy Tale of Home* (1845) tells of a fairy cricket.

Lady Jane Hunter, while visiting Fredericton, New Brunswick, wrote in her diary on Christmas Eve, 1807: "Tomorrow is Christmas; and the children are saying 'Oh, mamma, what do you think the fairy will put into our stockings?' Queen Mab is a Dutch fairy that I never was introduced to in England or Scotland; but she is a great favourite of little folks in this and other Provinces, and if they hang up a stocking on Christmas Eve, she always pops something good or pretty into it, unless they are very naughty, and then she puts in a birch rod to whip them with."

In the second half of the nineteenth century, fairies were placed on Christmas trees, with the thought that their tiny wings would fan out any fires ignited by candles set upon the branches. In 1850, Hattie Stowe, daughter of novelist Harriet Beecher Stowe, writes to her father of a fairy placed upon the family's Christmas tree.

In the mid-1800s, authors added new characters and details to their stories of Santa Claus, including tales of his wife, of Christmas elves and fairies, of a workshop and home for the Clauses at the North Pole.

1850: *The Little Messenger Birds, A Visit to The Dominions of Santa Claus* by Caroline H. B. Lang. In Santa's workshop "little creatures and curious little people" are making toys.

"If the little birds bring good news, they dart swiftly to the shoulder of Santa Claus, chirruping in his ear a few sweet notes. Then the little bells rejoice too, and ring out cheerily and merrily, while the fingers of the little workpeople move faster and faster, because it is such a pleasure, I suppose, to work for good children."

1855: Louisa May Alcott's 1855 journal confirms that she had finished a story called *Christmas Elves* and that it had been illustrated by her sister May. The work is a lost manuscript. May Alcott illustrated the first edition of *Little Women*. Alcott's 1822 work "A Christmas Dream" mentions Christmas fairies.

1857: "The Wonders of Santa Claus". Santa Claus/St. Nicholas lives with elves in a house of snow.

1863: "Santa Claus' Ball" - Santa Claus is "no longer a bachelor".

1873: *The Frost Fairies* by Margaret Canby. Fairies journey to Santa Claus.

1876: *The House of Santa Claus, A Christmas Fairy Show for Sunday School* by Edward Eggleston.

1881: "Mistress Santa Claus" by Margaret Eytinge.

Much you have heard about old Santa Claus,
But naught, I think, of his good-natured wife,
And I must tell you of her, dears, because
In sweet'ning life for you she spends her life.
She's small and plump,
her eyes are brown and bright,
And in a cave she lives that's full of toys,
Where, with her servant-elves,
from morn till night,
She's busy working for the girls and boys.
Yes, quite three hundred days out of the year
Never a single idle hour have they,
For well they know there would be many a tear
Should sugar-plums fall short on Christmas-day.
And oh! and oh! the sugar-plums!

1870: "Santa Claus and Joan" by Enna Beech, *Wood's Household Magazine*, January:

"My godmother was a Fairy Queen…." Mrs. Joan Claus.

1885: "Mrs. Kriss Kringle" by Edith M. Thomas, *St. Nicholas Magazine*, December:

"Of this lovely shy, old fairy…." (See P.2)

1894: "The Conquest of Santa Claus" by Caroline Creevy and Margaret Sangster. Elves rescue Santa.

1895: *Tiny's Christmas Fairy* by John Howard Hewitt. A fairy-child accompanies Santa Claus.

1902: *The Life and Adventures of Santa Claus* by L. Frank Baum. Santa in a world of nymphs, fairies and elves.

1906: *Santa Claus and all about Him* written and illustrated by E. Boyd Smith. Santa Claus is described as "our Winter Sun" and lives in a magical kingdom with little men.

1916: *The Mince Pie, Annabelle's Christmas Eve* by Josephine Scribner Gates, illustrated by John Rae. A fairy explains gifting to a girl.

1918: *The Fairy Who Believed in Human Beings* by Gertrude Kaye. A fairy finds the meaning of Christmas.

Credit: P 94.

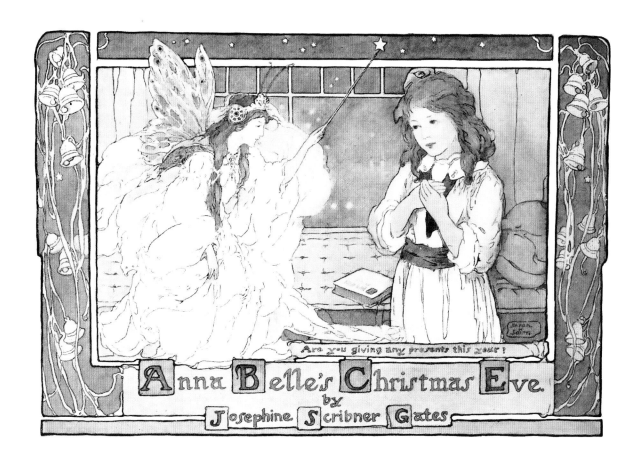

1925: "A Christmas Card" by Kate Douglas Wiggins

I dreamed one night the Christmas Fairy
stood beside my bed;
A crown of golden tresses made a
halo round her head;
Her eyes, like winter stars they gleamed
beneath a brow of snow;
Her cheeks were holly clusters;
her mouth, a Cupid's bow;

And, oh! there beamed upon her face,
in most bewitching way,
The smile that happy children wear
when waking Christmas day.

Reverend Robert Kirk, in his seventeenth century manuscript *Secret Commonwealth,* wrote of elves, fauns, and fairies. *Trinarchodia,* written by George Daniel in the mid-1600s includes a description of the women of Lapland as "those elves".

J. R. R. Tolkien, Hans Christian Anderson and C.S. Lewis, along with many other writers of the nineteenth and twentieth centuries, wrote of the magical realm of fairy folk characters.

Credit: *Annabelle's Christmas Eve*
by John Rae, 1916.

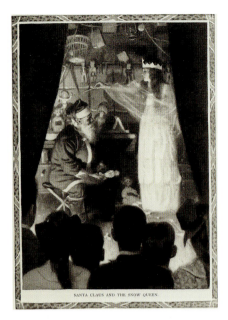
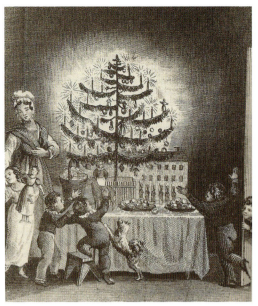

The twists and turns of time have not dampened the desire for creative responses to the oncoming season of howling winds, and dark frosty nights that stir the imagination. Through the centuries, hope, comfort and joy have been fostered around the fire and hearth, with stories shared and songs sung of magnificent inspirational characters. For two centuries the Clauses have been central characters in stories read at Christmas. The compassion and merriment the pair represent and the imaginative world they inhabit — a world of elves, magical reindeer and fairies — will continue to delight and inspire. As characters of both the secular and non-secular worlds, their stories are threads in a brilliant cultural tapestry that share values of Western Civilization with children. They are important characters for the loving kindness they represent, and for stirring the imagination in young minds.

Charles Dickens emphasized the importance of fancy in his 1843 essay "Fraud on the Fairies":

We must assume that we are not singular in entertaining a very great tenderness for the fairy literature of our childhood. What enchanted us then, and is captivating a million of young fancies now, has at the same blessed time of life, enchanted vast hosts of men and women who have done their long day's work and laid their grey heads down to rest. It would be hard to estimate the amount of gentleness and mercy that has made its way among us through these slight channels. Forbearance, courtesy, consideration for poor and aged, kind treatment of animals, love of nature, abhorrence of tyranny and brute force—many such good things have been first nourished in the child's heart by this powerful aid. It has greatly helped to keep us, in some sense, ever young, by preserving through our worldly ways one slender track not overgrown with weeds, where we may walk with children, sharing their delights. In an utilitarian age, of all other times, it is a matter of grave importance that Fairy tales should be respected. Our English red tape is too magnificently red ever to be employed in the tying up of such trifles, but everyone who has considered the subject knows full well that a nation without fancy, without some romance, never did, never can, never will, hold a great place under the sun....

Credit: *The Stranger's Gift*, 1836.
Santa Claus and the Snow Queen, 1915.

"Christmas Day"
by Margaret E. Sangster, 1896.

Of all dear days is Christmas day,
The dearest and the best;
Still in its dawn the angels sing
Their song of peace and rest,
Which beings to simple earthly homes
Heaven's light on Christmas day.
Then, deep in silent woods, the trees–
The hemlock, pine, and fir
– Thrill to the chilly winter breeze,
And waft a breath of myrrh;
And far and near Kriss Kringle's bells
Their airy music shake,
And dancing feet of boys and girls
A sweeter joyance make.

Credit: *Christmas* by M.T. Ross, 1914.

CHAPTER 2 - THE LITERATURE

This publication is the result of a literary sleuthing endeavor that sought to compile the library of literature for the character Mrs. Claus. Works were located online, as well as in first-source materials, including vintage periodicals, newspapers, journals and books. The results of a search for works published in the nineteenth century were surprisingly rewarding. "Mrs. Santa Claus and Jessie Brown" published in 1869, was a remarkable find, as where the Mrs. Claus stories, written by authors with opposing views on the merits of the women's suffrage movement. A select group of short stories and poems are reprinted in this publication, each chosen for their significant contribution to the legacy of Mrs. Claus. Other referenced works are available online or through libraries and archives.

1849: In *A Christmas Legend, Mysteries of City Life,* J.W. Moore, Philadelphia, PA, written in 1849 by James Rees, readers are introduced for the first time to the wife of Santa Claus.

"Hush sir," exclaimed the laughing couple, "recollect this is Christmas morn, and we now appear, not as old Santa Claus and his wife, but as we are, the mere actors of this pleasing farce."

1851: Mrs. Claus was first mentioned by name in *Holiday Week* (December), in the *Yale Literary Magazine*, New Haven, CT, with the initials "A.B.": "After Christmas dinner, guests assembled and a small, decorated tree was brought in. There appeared near by the tree an old man with bent form and a cane. Suddenly, in bounded that jolly, fat and funny old elf, Santa Claus. His array was indescribably fantastic. He seemed to have done his best; and we should think, had Mrs. Santa Claus to help him."

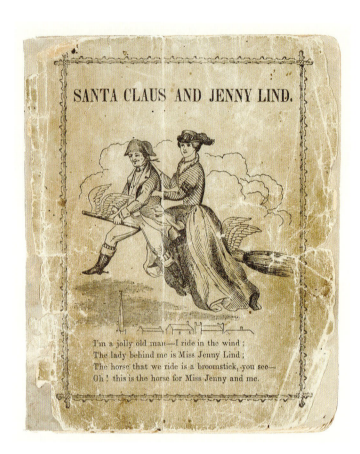

Credit: *Santa Claus and Jenny Lind,*
P.T. Barnum tour pamphlet, 1850.
Swedish songstress Jenny Lind toured America in 1850.

1854: Mrs. Claus' debut on stage was in a production, written and performed by patients at The New York State Lunatic Asylum in Utica, NY, published in the institution's magazine, *The Opal*: "A pause was had, and a solemn stillness pervaded the assembly; the ringing of a bell announced the approach of Mrs. Santa Claus and her baby and with great joy they were greeted, and her Ladyship joined in the dance; and committed to our care with sweet baby - and we kissed it."

1862: "Editor's Easy Chair", *Harper's New Monthly Magazine,* February.

Excerpt:

When the gas was turned down and twilight was almost lost in sight, there was the magnetic thrill of expectation in that little company, which you have known, if, when you were a child, you heard the prompter's bell. After an age of a minute that wicked door was opened, and there stood the beautiful, benignant Christmas-tree. For a moment the hush of the children and the calmly burning tapers made it seem almost an alter and the little crowd worshipers…. And if we were so, how much more so the kind genius of the tree! Not the little cherub up aloft, but she who put him there - she who for so many hours and so many days had been industriously and ingeniously designing and working to please us all. Whether any of us looked at her with secret awe, believing that we beheld Mrs. Santa Claus herself, we have never told. But surely, she provides a merry Christmas for herself who makes so many children of every age happy.

1864: Mrs. Claus appears in a dream in the novel *The Metropolites* by Robert St. Clar.

Excerpt:

"…and I fell asleep after breakfast, thinking of my misfortune, when Santa Claus sent his wife to see me on the subject."

"She had on Hessian high boots, a dozen of short, red petticoats, an old, large, straw bonnet – and such a bonnet, Morton!"

Credit: *The Real Santa Claus* by Lucien Davis, *London Illustrated News,* 1898.

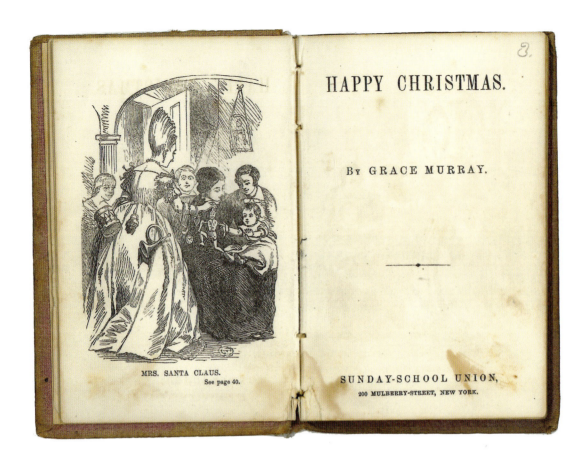

1868: "Happy Christmas" by Grace Murray.

Excerpt:

Dear Aunt Kitty: I love to please the children, O very much! And I have my own way of doings things. I don't often go to see folks. I stay at home to fix up things for Santa Claus to carry around. But if your children are very good, and if I feel in the humor, I may come to your house about seven o'clock on Christmas night. I love to make everybody happy, so I may take a notion to give some things to big folks and let them have the pleasure of giving them to the children. My heart is just as big and kind as Santa Claus's is, and if I come, we will have grand times. You may hang up your stockings on Christmas eve, and if you do not find anything in them on Christmas morning, you may know I am coming with a pocket full of money and a heart full of love. Mrs. Santa Claus.

Mrs. Claus is portrayed as an aunt in disguise.

Credit: *Happy Christmas,* 1868.

MRS. SANTA CLAUS AND JESSIE BROWN

1869: "Mrs. Santa Claus and Jessie Brown," is the first identified work to portray the character of Mrs. Claus, as a character in her own right. (Illustration P.6)

You've heard of good old Santa Claus? ay,
doubtless, all your life;
Though not of him I'm going to tell,
but of his lovely wife.
And pretty little Jessie Brown,
an orphan, you must know:
The story as told to me a long, long time ago.
One stormy night – 'twas Christmas-time –
when all the children round
Hung up their stockings, knowing well
with treasure they'd abound;
They scampered laughingly to bed, to dream away the night,
Their little hearts all fluttering with gladness and delight.
But there was one poor little girl - her name was Jessie Brown -
Who with her dear grandfather lived here in Brookhaven town;
But he was old and very poor, and oft his tears would fall
Upon the little face of her,
his darling one, his all.
This Christmas-eve their scanty meal was eaten in the dark,
Yet Jessie looked as bright and glad as
any singing lark;
And when beside her grandpa's knee she lisped her evening prayer

She looked so sweet you would have thought an angel had been there;
Then with the good-night kiss she crept into her "trundle" bed,
And, smiling, asked, "Will Santa Claus come, now mamma is dead?"
"I hope he will," her grandpa said, and turned away his head;
Then, on a nail hung up with care, her stocking he soon spied,
With many a threadbare patch, although to mend it she had tried;
And when he thought her fast asleep he took it from the nail,
And by the fire-light you could see his face looked strangely pale.
His fingers trembled as he sighed, "My precious little dear!
Oh, would I had a thousand crowns! I'd put them all in here."
Then in the stocking dropped some nuts, and hung it up in haste,
And, walking to the door, looked out upon the dreary waste.
But as he looked a beauteous form before him did appear;
It was a lady, but she seemed as from some other sphere.
Her mantle all embroidered o'er with glist'ning flakes of snow;
Her hair like sparkling strings of pearls or dew-drops seemed to grow;

Upon her feet were sandals bright of frost-work, such as seen
At morn, when glints of sunlight fall upon the blades of green;
And oh! her eyes they were so bright!
Like twinkling stars they shone;
As in the gentle, dove-like voice,
her errand she made known.
"I'm the wife of Santa Claus,
and with him came to town,
Because I wished so much to see
sweet little Jessie Brown;
You'll not refuse me, I am sure,
an entrance at your door;
The good I give the choicest gifts
out of my bounteous store."
Then from her head a string of pearls
she hastily unwound,
Each pearl a virtue was, their like elsewhere were never found;
And from her pocket forth she drew an hour-glass filled with sand,
That into gold gowns would turn
if touched by Jessie's hand.
Then in the stocking, worn and old,
she let the jewels fall,
With many other wondrous gifts
too numerous to recall,
And filled it up with sugar-plums,
the sweetest e'er were known,
And whispered soft in Jessie's ear,
"These things are all your own."
A low, sweet whistle then was heard -
'twas Santa Claus they say,
Who, waiting all the while outside,
now called his wife away.
To every house they went that night
throughout Brookhaven town,
But none such priceless gifts received
as little Jessie Brown.

Published in *Harper's Weekly,* January 9, 1869.

1870: "Santa Claus and Joan" by Enna Beech, *Wood's Household Magazine,* January:

Dear Santa, once more smile,
I can charm the reindeers' hurts away;
And if you'll listen a little while
I will make your sad heart light and gay.
My godmother was a Fairy Queen….
And she came to me on our wedding day
To wish me joy, from her own fair land." -
"So take, dear child, with my wishes kind,
This little purse for a wedding gift;
In days to come you may sometimes find
Sorrow and care from your heart 'twill lift.
'Tis a fairy purse, and is always full;
And if ever Santa Claus wants more gold,
He has only the silken string to pull,
It will give him all that his hands can hold."

A collection of stories featuring Mrs. Claus, written in the second half of the nineteenth century, reflect the growing interest in feminism in American society at the time.

Charles Dickinson's "Mrs. Claus' Adventure" (1871) and M.R. Horton's *New Departure* (1879) were stories that pushed back on the crusaders. Mrs. Claus is presented as a supporter of women's rights in Sarah Burke's "Mrs. Santa Claus Asserts Herself" (1883). In "Goody on a Sleigh Ride" (1888), Katherine Lee Bates presents Mrs. Claus, in the first person, wanting her own adventures, including joining Santa on his gleeful sleigh rides. Stories written in the nineteenth century of an ingenuous and brave Mrs. Claus character, led the way for her to become a lasting icon of the women's rights movement.

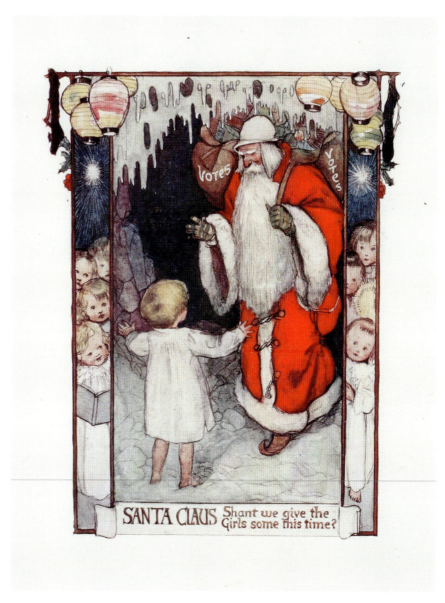

Credit: *Equal Suffrage, Life Magazine* by William Henry Walker, 1911. *Santa Claus Votes,* 1910.

1792: Mary Wollstonecraft spurred interest in feminism by writing *The Vindication of the Rights of Women.*

1832: Maria Stewart was one of the first American women to publicly call for the vote for women.

1845: Margaret Fuller's *Woman in the Nineteenth Century* was the first major feminist work written by an American.

1848: Elizabeth Cady Stanton and Susan B. Anthony organized the first women's rights convention, held in Seneca Falls, NY.

1868: Susan B. Anthony produced *The Revolution,* the first American periodical to focus on women's rights.

1870: "The New Departure" advanced that women had the right to vote under the United States Constitution and was presented by Victoria Woodhull to the House Judicial Committee, where it was rejected. She was the first woman to seek the office of the President of the United States.

1920: American women gained the right to vote with the ratification of the Nineteenth Amendment.

1965: The Voting Rights Act, removed residual requirements, poll taxes and literary tests.

Credit: *The Star-Spangled Banner,* Currier and Ives. Photographed by David Stansbury. Michele and Donald D'Amour Museum of Fine Arts, Springfield, Massachusetts. Gift of Lenore B. and Sidney A. Alpert, supplemented with Museum Acquisition Funds.

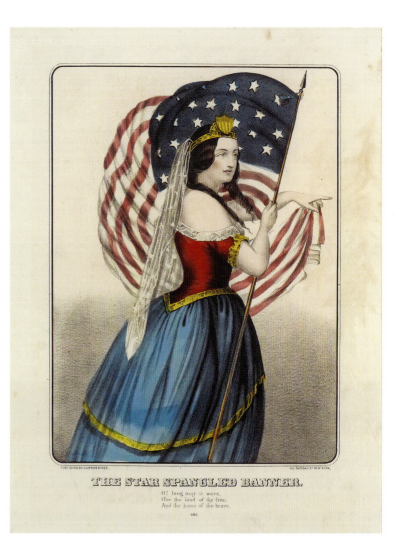

MRS. SANTA CLAUS' ADVENTURE

1871: "Mrs. Santa Claus' Adventure" by Charles S. Dickinson. The Author cautions women from moving beyond the realm of domesticity.

"There, Santa, don't you grumble so,
You know it isn't right,"
Said madame Polly to her spouse,
One bleak December night,
"What matter if the children be
Increasing on the earth,
And stockings multiply by scores
Around the chimney hearth?
I'm sure I feel almost compelled
To box your naughty ears
For talking as you have to-day
About the precious dears."

At this old Santa shook his head,
Laid by his pipe, stood up, and said:
"Now, Mrs. Claus, I've lived with you
Through many a Christmas season;
You know I'm not inclined to scold
Without sufficient reason.
Had you but ridden round with me
Through every Christian nation,
And entered by the chimney top
Each mortal's habitation:
Had you but seen what I have seen
Of this small generation:
Had you but heard the youngsters talk,
You'd have no hesitation
In calling them, - to say the least,
A wonder of creation.
Tis not because they multiply
So fast, that I'm complaining;
Ah, no, indeed ! I'm always glad
To see their numbers gaining.
What troubles me of late is this –
A serious trouble too:

You know the naughty words and deeds
That children say and do,
Are hidden deep, by Nick, the imp,
Within the chimney flue;

And thus sometimes they get so full
That when, at Christmas eve,
I seek to find an entrance there,
I'm sadly forced to leave.
I've often tried to press my way
Down through the mottled throng;
But find it hardly pays to face
The saucy imps of wrong.
I know the chimneys nowadays
Are smaller than of yore;
The children should remember that,
And guard their actions more.
For this result must come at last:
If chimneys still decrease,
And children will persist in wrong
My gifts to them must cease."

"Oh, fiddlesticks!" returned the spouse,
With quite a wifely pout,
I don't believe it's half as bad
As you would make it out.
A chimney full of naughty deeds!
Well now, whoever heard
Such wicked slanders from your lips!
Pshaw, Santa! 'tis absurd!"

"Absurd but true, I grieve to say:
And if you choose to doubt it,
Just go yourself, next Christmas eve,
And learn the truth about it.
The presents, sledge, and Snow-flake too,
Are at your service, dear,
I'll tend the kitchen while you're gone,
And keep things cozy here."
"Indeed! – that's fair," said Mrs. Claus,

" 'Tis very kind of you,
I'll go, and mind, I'll make my way
Through every chimney flue."
The days rolled on; and Madame Claus,
With Santa's help, from trunks and drawers,
Brought out the Christmas treasure:
Great, life-like dolls with flaxen curls
Adorned with silks and mimic pearls,
Red lips, and eyes of azure,
Gay cards, and books with gorgeous plates:
Nuts, candies, raisins, figs and dates,
And toys a boundless store.
There, in the grand old Christmas hall
In Santa's house, the presents all
Lay scattered round like leaves in fall,
On tables, chairs, and floor.
At length it came: That Christmas Eve;
And in the hall, prepared to leave,
Warm clad in downy wrappings
Stood Mrs. Claus, and Santa, too,
Who on a silver whistle blew,
When instantly wide open flew
Two folding doors; and bounding through
A snow-white reindeer came, who drew
A sledge, ablaze with gold and blue,
Bedecked with silver trappings.
Five roguish sprites, a merry band,
Come tripping out and take their stand,
Awaiting Santa Claus' command
To fill the fairy sleigh.
Then, at his word the nimble boys
Seize dolls and dainties, books and toys,
And stow them smug away.
"Aha!" laughed Santa, "That's the gear
To make the children jolly."
Then to his wife he said: "Step here;
We're ready for you, Polly.
The midnight hour is drawing near,
I smell the Christmas holly.
Now mind your p's and q's, my dear,

And keep yourself from folly.
You'll find, in there, a silver horn
To blow, in case you need it;
And yon, ye sprites, keep open ears,
And when you hear it, heed it!
Now kiss me, dear, and hasten on!
I'll keep the kitchen cozy.
Come back when o'er the eastern hills
The sky is growing rosy!"
"I will," returned the worthy dame;
"And not a stocking leg
Throughout the land, shall empty hang
Upon its fireside peg.
Good-bye, good-bye! Ge up, Snowflake!
Don't keep me waiting here!
The children sleep,
The Elfins keep
Their slumbers deep.
No eye will peep
While I glide down the chimney steep,
Nor have I aught to fear."
On sped the reindeer o'er the snow;
The winds could hardly faster go
On, on, till Madame shouted, "Whoa!"
In front of Pinewood Hall.
An instant, and his tiny hoof
Was clattering on the slated roof;
Another instant, and he stopped
Beside a chimney tall.
Then Madame Claus, with scare a pause,
From out her hoard of prizes,
Selects a host of wondrous toys
Of wondrous shapes and sizes:
Enough to load the mantle-piece,
And cram each pendant stocking;
Then with a smoke she mounts the flue,
But ah, alas! - 'twas shocking!
for there, protruding, like the nest
Of some gigantic swallow,
A great black falsehood stowed away,

Half filled the spacious hollow,
That story Gertrude Means had told,
Three weeks ago or more;
And Nick, the elf, had captured it,
And placed it for a door
Just at the opening of the flue,
To guard his hoarded store
Of "Wont's," and "Cant's,"
And fretful "Shant's,"
Collected by the score.
Poor Mrs. Claus was quite perplexed
At this untoward dilemma;
And if she seemed a little vexed,
We surely can't condemn her.
"Well I declare!" the dame begins,
"Tis shameful in you, Nick,
To use the little folks' sins
To plaster up the brick.
Ah, could I only have the chance
To lay my hands on you,
I'd seize you by your wicked ears
And hurl you down the flue!"
"Indeed! And would you now?" said Nick,
Emerging into view
A wire, nimble, jaunty sprite,
Whose piercing eyes, so black and bright,
Shone through the darkness of the night
With such a strange unearthly light,
That madame Claus shrank back in fright,
Exclaiming, "Mercy me!"
"Ha!" chuckled Nick, in great delight,
"You've changed your mind, I see.
Well, don't you fret yourself, my friend,
But tell me, what's your name?"
"I'm Mrs. Claus, Sir, if you please,"
Replied the frightened dame.
"Ah, Santa's wife. I understand.
You're going down below?"
"That's my intention, Sir; but then
You've filled the chimney so

That I'm not sure of getting through,
If I attempt to go."
"But that's the children's fault," said Nick,
I'm not to blame, you know."
"You are!" said Mrs. Santa Claus,
Whose cheeks began to glow;
"But I'll not waste my time with you,
I'm going down the flue.
In spite of all your tricks can do,
I'll find a passage through!"
Then with a jump,
She landed plump
Upon that awful whopper;
And strange to say,
Like yielding clay,
It neither chanced to block her way,
Or for an instant stop her
But ah, poor lady! She was doomed
To meet a sad mishap.
When half way down, she tripped and fell
Upon a treach'rous trap,
Placed there by Nick
When truant Dick
Forsook his school for play
And filled with all the naughtiness
Of that eventful day.
Strange beings flit before her eyes:
Embodied thefts and mean white lies,
Minute, but all tormenting.
Around her head they fly and shriek:
Assault her ears with many a tweak,
So small, yet unrelenting.
In short, good Santa's valiant wife
Was in a peck of trouble.
Sly Fun and Mischief, saucy imps,
Had bent her glasses double;
Another still, called Selfishness,
The pet of Kate and Fanny,
Had snatched away the Christmas gifts
And hid them in a cranny.

And soon the dame begins to choke;
For heavy clouds of noisome smoke
Come floating up the flue.
Ah! Johnny, ah !
That first cigar
Is smoking still for you.
Just here a buzzing fills the place;
And ere the dame can wink,
Another troop comes pouring forth
From crevice, nook and chink.
They circle round poor Polly's head
With many a wond'ring blink;
Like monstrous bumble bees in shape,
And all as black as ink.
These are the angry thoughts and words
Of Gertrude, John, and Dick.
Each holds within its tiny hand
A slender pointed stick,
And, in their flight, they now and then
Just give the dame a prick.
Ah do you wonder, little folks,
That she is faint and sick?
At length, when all her cries are vain,
She blows her silver horn; -
And lo! The chimney flue is cleared,
The hateful imps are gone.
An instant, and the merry sprites
From Christmas hall are come,
Who raise her gently in their arms
And bear her swiftly home.
They placed her in the big arm chair,
Excited, torn, and humbled;
She does not blame old Santa now,
Nor wonder that he grumbled.
"Ha, Ha!" laughed he, " So you confess
That children have their failings;
You've lost your specs, and torn your dress;
But what you've learned, if I may guess,
Will save me sundry railings."

"Upon my life!" returned his wife,
"I really can't contrive
How you get through that chimney flue,
And find yourself alive."
"Aha, my dear,
The secret's here:
I seldom venture down,
When I espy
A theft or lie
Upon the chimney's crown.
Where these abound,
I've always found
That other sins have grown;
And have by sad experience learned
To let such flue's alone,
But now it seems that I must do
The work which you begun:
Must traverse both the continents
Before the rising sun.
Well, here I go! Come on, Snow-flake!"
Cried he, with merry shout;
"The good shall have their gifts to-night,
The bad shall go without.
Away! Away!
The breaking day
Must find our task completed;
And all good little boys and girls
To toys and dainties treated.
O'er ice and snow,
We swiftly go,
From lake, to gulf and isthmus.
Ye mortals all,
Both great and small,
Throughout the land,
From strand to strand,
A right good MERRY CHRISTMAS!"

Published in *Wood's Household Magazine*, December 1, 1871.

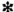

MRS. SANTA CLAUS' RIDE, A CHRISTMAS TALE FOR CHILDREN

1874: "Mrs. Santa Claus' Ride, A Christmas Tale for Children" by Georgia Grey.

Excerpt:

Old Mr. Santa Claus came home late Christmas Eve and slammed the front door with such a vengeance that his wife and several little Clauses rushed out of the bedroom, pell-mell, to see what was the matter….

"Must you go out again?" inquired his wife, bringing him the desired article. "Go out again?" echoed Mr. Claus, rather indignantly. "How simple-minded you are. It seems to me, madam, that you have very little idea of my laborious duties. But of course, you, being a woman, can't understand anything about the hardships I have to endure. He sighed, and tried very hard to look like a martyr, as he undoubtedly considered himself just at that moment; but the effect seemed entirely lost upon his good wife.

"I'm very sure I know what labor means," she replied. "I work like a slave all the year to prepare the presents you are so fond of scattering at Christmas; and I only wish I could have the privilege of sharing your toils then. But I suppose no one ever expects to see Mrs. Santa Claus." "No one knows of your existence, even," said her husband. "You know there isn't room for two of us in my sleigh, when it's loaded down with everything under the sun; so, what is the use of talking? I am not a woman's rights man; I consider that your proper sphere is at home. You are an excellent person-in your place, however, my dear. Will you bring my pillow, my love?"

No wonder Mr. Santa Claus began to smile benignantly and thought best to call to his aid a few endearing terms. His wife's eyes were sparkling ominously, and he really couldn't spend time to quarrel, just then. So he patted his fat knees affectionately, yawned twice, and declared he was so sleepy he couldn't keep awake.

"Lie down then," said his wife; "and while you are asleep I will, with your permission, of course, take a short ride." She looked decidedly as if she should take a ride, whether she had permission or not.

Now old Santa Claus was really not a remarkably courageous man, in spite of his prodigious size, and he actually didn't dare, just at that moment, to command his wife to stay at home, and let his reindeer alone. He felt, somehow, that it wouldn't do any good; so he simply stared at her in silence. At last he ventured to suggest that she would get run away with and break her neck.

"Break my neck, indeed!" repeated Mrs. Santa Claus. "Don't you suppose I know how to drive?" Then they glared at each other a few minutes more….

"Now is my time," thought his wife; and she hastily wrapped herself in many shawls and cloaks, packed up a few simple articles for gifts, took a peep at her sleeping children, and then went softly out into the night.

The wind blew sharp and cold, and scattering snowflakes, drifting through the air, seemed to seek in vain a resting place. The stars peered now and then through the clouds, but there was no warmth in their pale light. Mrs. Santa Claus shivered and looked back over her shoulder at her comfortable home; but she was not one to yield easily to every discouragement.

How eagerly the reindeer pawed the air! And how they flew forward, the instant the reins were loosed! Their new driver was really a little startled, at first, and could hardly control them; but they soon became more tractable and seemed perfectly willing to be guided by feminine hands, "Ah," thought Mrs. Santa Claus to herself, this is indeed rare sport for me. Santa Claus ought to be a happy man, surely women might go abroad, once in a year, and aid in these errands of mercy. But Santa visits the wealthy, who have already enough to spare. How much better it would be if all the most valuable presents could be made to the suffering poor. I would the power were all in my hands; and never a poor little hungry children show'd want for food on Christmas night; never should a wretched man or woman be shut up alone in their poverty, without some token to make them rejoice on this great birthday….

The "off dew" was rather frisky, as his master had informed her, and it required all her attention for a few moments to keep from being upset; and before she was aware of it, she was driving into the front yard of a little cottage, in the neighborhood of a large village; when she was suddenly jerked from her seat, and landed, headfirst, in a snowdrift. When she at last succeeded in recovering an upright position, after a good deal of floundering about, and puffling and scolding, she stood still a moment, and pensively regarding her capricious steeds. A trifle less conceited was poor Mrs. Santa Claus, as she stood there, waist deep in snow, watching the reindeer toss their horns and stare at her in astonishment. Such proceedings were entirely beyond their comprehension. Then Mrs. Santa Claus discovered that she was near somebody's windows, and that a faint light was shining out, right into her very eyes….

Poverty was written on the meager furniture, the bare walls, and uncarpeted floor. And poverty was stamped on the faces of the man and woman who kept their lonely, silent watch at that evening hour. The man was evidently an invalid, for he lay on the couch, his eyes were closed, his cheeks were sunken and pale, and his hands thin and bony. Long sickness must have done its work faithfully, to make such a wreck of a man's strong frame.

The woman too, looked frail and worn, sitting by his side, and stitching, stitching, with such monotonous regularity, as if her soul was locked up, out of sight, and her hands kept moving on mechanically. Six little stockings were hanging in a row, limp and empty, beside the brick fireplace. The smallest was such a tiny thing, bearing the impress of a baby foot, and the largest could not hold many Christmas gifts. Six little faces, pressed to their pillows, saw nothing of the agony in their parent's hearts at that dark hour.

"Ah," sighed Mrs. Santa Claus, "what a pitiful sight! How could

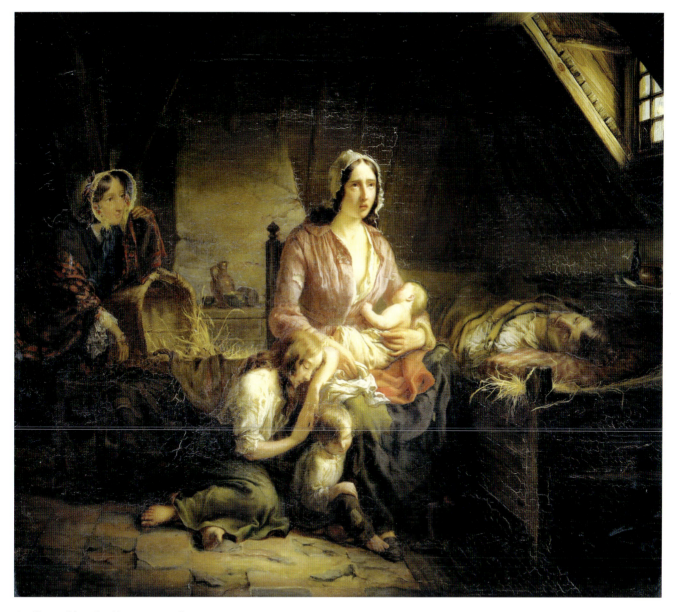

Credit: *A Rich Lady Visits a Poor Family* by Gerardus Terlaak, 1853.

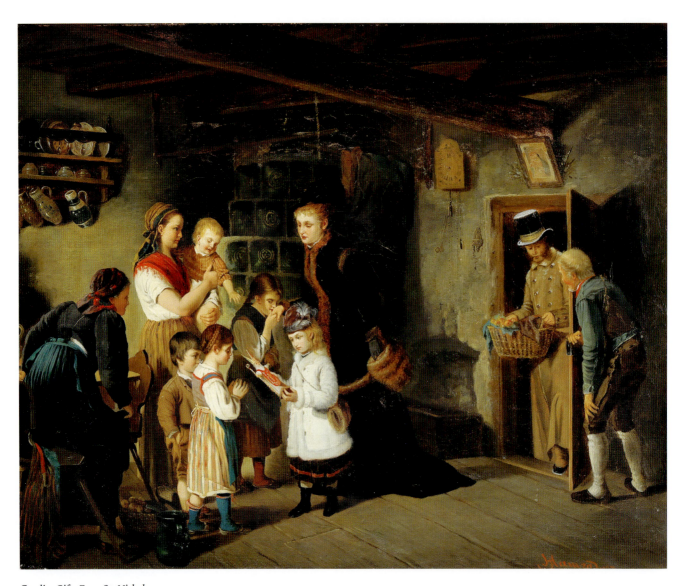

Credit: *Gifts From St. Nicholas* by Johann Hamza, 1900.

Santa have the heart to pass by those dear little stockings? They shall be filled, from top to toe, as sure as I'm a woman."

The candle burned low, and the woman laid aside her work. The sick man opened his eyes and pointed with a feeble hand to the expiring fire. The woman drew her shawl more closely about her shoulders, then bowed her head upon her hands, and moved her lips in prayer. It was surely answered.

About a mile away, in the midst of a prosperous town, there was one mansion, a little more stately and more elegant than any of its neighbors, on Christmas Eve, with its darkened windows and gloomy grounds.

The inmates were all asleep, save a gray-haired man and a little boy, master and servant. They occupied a cozy room on the lower floor, and one of the windows, opened a little to admit fresh air, affording a fine opportunity for outsiders to peep within. The master seemed busy with his own thoughts and paid no attention to his little office-boy, who sat by the window, drumming softly with his fingers, and humming a Christmas carol. In truth, though the master was hard and proud, he had a tender spot in his heart for the little orphan boy he had picked up in the streets and allowed him to follow his own inclinations usually.

That evening the boy had been permitted to stay in his master's library till it was almost midnight, watching the merry groups that continued to pass to and from on the streets. His eyelids began to grow heavy, the hours wore on, and he laid his head for a moment in the open window to listen to the chiming of the Christmas bells. Someone stood by the window, though he was unconscious of it, and some one whispered in the boy's ear, "ask your master to remember all the poor and sick." The boy started and rubbed his ear briskly; he supposed it to be one of his own thoughts. But he could not forget it, and somehow it drove all his sleepiness away. He walked to his master's side and gently touched his on the arm. "What is it, boy?" asked the man, not unkindly.

"Sir, a year ago I was suffering with cold and hunger; and, sir, I cannot forget others who are not so comfortable as I am to-night. Sir, will you, too, remember the sick and the suffering? You have much money, sir, and no children. Those little graves, over yonder, will never need your money, sire. You might comfort a great many people on Christmas Eve, if you would. That poor woman brought home your shirts today, sir, and she said her husband was quite sick, and she needed the pay very badly; but your wife didn't pay her, sir. She said they hadn't anything to make happy Christmas for the children, and Santa Claus never visited them. She said so, sir, with tears in her eyes."

The gray-haired man turned his proud face away for the moment. He pocked the fire. He trod on the dog's tail. At last, he rose from his chair and walked out into the kitchen, John and Mary, his faithful old servants, were both dosing before the fire. "John!" cried the man. "John! I say." And John stumbled to his feet. "Fetch the horses, and away with you!" "What, sir?" "I mean, take this money to that poor woman who sews for my wife, and carry a load of fuel and provisions. What are you staring at, you idiot?" John knew his master was not given to acts of benevolence, and he was dumb with astonishment. But the man offered no word of explanation, and with a grim smile he walked back to library.

Old Mrs. Santa Claus, out in the yard, chuckled gleefully at the success of her attempt and leaping into her airy seat she turned her face homeward.

"Time up so quick?" grunted Mr. Santa Claus, when his wife shook him by the shoulder, and informed him her neck was still unbroken. "I've been absent just an hour," she answered, "and won't you please look in at Mrs. Bateman's, who lives in the suburbs of Busytown, and see how they are prospering."

Santa Claus did peep through the ragged curtains of Mrs. Bateman's window, a few hours later, and this is what he saw: A large bundle of toys, sweetmeats, etc., such as he usually carried himself, was lying on the floor, while its contents a pale woman, with a smiling face, was eagerly filling six little stockings, even to the extent of showing gaping holes in the toes. A sickly-looking man was rubbing his hands together joyfully. Strewn around the floor were articles of all kinds, too numerous to mention, from wood and potatoes to jellies and cake. Santa Claus couldn't comprehend the case; but when the day was done, and he was snuggly seated at home, once more, he demanded an explanation. "I declare, wife," he said, "I believe you turned out on their doorstep every blessed thing you carried, you extravagant woman. The idea of leaving such a quantity of toys and candy in a poor little family like that! But where the cartload came from, I'm sure I can't conceive." Then Mr. Santa Claus had a lecture; and it must have been a very severe one, too, for before its close he meekly' lopped his ears," and said, "yes, to everything she required. Therefore, and consequently Mrs. Santa Claus firmly believes that when another Christmas rolls around her husband will display a never heard of before benevolence to the poor.

Published in *Zion's Herald* on December 17, 1874.

1875: "Mr. and Mrs. Santa Claus" by Sara Conant. Mrs. Claus is portrayed as indispensable and helping with joint work.

1878: *L'ill in Santa Claus Land* by Ellis Towne, Sophie May, and Ella Farman.

"There was a lady sitting by a golden desk, writing in a large book, and Santa Claus was looking on through a great telescope, and occasionally, he stopped and put his ear to a large speaking-tube. Then he said I might look through the telescope, and I looked right down into our house. There was mother very busy and very tired, and all of the children teasing. It was queer, for I was there, too, and the bad-est of any."

"Yes, mamma," I answered, 'I'll come right away.'

"As soon as I said this Santa Claus whistled for 'Comet' and 'Cupid,' and they came tearing up the tower. He put me in a tiny sleigh, and away we went, over great snow-banks of clouds, and before I had time to think I was landed in the big chair, and mamma was calling 'Lilian, Lilian, its time for you to practise,' just as she is doing now, and I must go."

Effie sank back in the chair to think. She wished L'ill had found out how many black marks she had, and whether the lady was Mrs. Santa Claus – and had, in fact, obtained more accurate information about many things.

Credit: *L'ill In Santa Claus Land,* 1878.

NEW DEPARTURE

1879: *New Departure* by M. S. Horton.

Excerpt:

There appeared in the drawing-room of a home well-filled with children, a somewhat startling, majestic figure, who carried upon her shoulders a good-sized pack, and whose dress was of a most fantastic style. Upon her head she did not wear a "wreath of roses," but a lofty pasteboard turban, covered with Turkey-red, and emblazoned with large newspaper letters, spelling "Woman's Rights!" the interjection point, in very red ink, extending from the turban's top to its base....

She came forward into the midst of the merry group, a most unexpected, but not alarming visitor, and with a stately air and ringing voice declared: "For about 1800 years that rotund tramp, St. Nicholas, has been enjoying himself hugely on Christmas Eves by wandering here and there with his reindeer and his gifts, making himself greatly popular with both young and old. Allow me to say that is quite high time that Mrs. St. Nicholas should be allowed some privileges! And if she is not allowed, she will take them!"

"Let me announce to you, both young folks and old, that I am Mrs. St. Nicholas, the sharer of my husband's sorrows over broken toys, but never a sharer in his Christmas joys. Plodding on for so long in my retired home, I have inhaled the new atmosphere of the world with a good, long, earnest, and life-inspiring breath – that new atmosphere which makes a woman as capable and vigorous as a man – which starts the pulse of Mrs. St. Nicholas, and brings her before you with the determination to win your smiles and praises, as Mr. St. Nicholas has been accustomed to receive them from the world since the advent of Christmas gifts."

"I appear before you," she continued, in a softer tone, "as a most injured and long-patient woman, now claiming your sympathy for her wrongs. If the old and young Santa Claus could tell their tale, they would give centuries of detail concerning stockings darned, shoe-strings continually tied up, and buttons sewed on, while Mr. St. Nicholas was being petted and praised for his charring liberality at the Christmas holidays – 1800 years of dull home life for the one, and a merry tramping all over the world for the other!"

"You must certainly wonder at the patience and forbearance which have lasted so long, rather than cherish any surprise that injured woman should at last rebel and start out alone to seek the road to love and fame."

"The favorite Santa Claus, puffed up with joviality, and reigning like a king at Christmas time, must share his throne with one who can wear a crown with much more dignity than he. He has made his pretty toys, and has tumbled them down the

chimney, all by himself, quite long enough. It's my turn now to win some hearts, and fame, and poetry."

Mrs. St. Nicholas distributes presents for members of the Brown family. A trick has been played on Mrs. Claus and instead of "Oh's" and "Ah's" of delight, she is asked to explain the meaning of a gift of a giant turnip and a bag of dough.

For a moment the figure paused, but then, coming briskly forward, appeared as the vulnerable St. Nicholas himself! ….

"So, you thought you would bring the Browns their presents, did you?" ….

"When Mrs. St. Nicholas thinks so much of a remarkable start in the direction of Women's Rights as to talk about it aloud when she imagines herself alone, that tyrannical Old Nick must look out steadily for his own endangered ways….".

He was at this point of his discourse suddenly interrupted by Mrs. St. N., eager to establish the existence of a new feminine power….

"I hear that somebody who reads the stars, declares that before another Christmas day comes round, there will be a fresh and mighty start of womankind toward the goal of freedom! Ah, that will be the day and hour for Mrs. N.'s, and others' powers! My dear old Nick, let all the past become a blank, because of that good time coming – my dear old Nick, come to my arms!" Mr. St. Nicholas jumped up with youthful alacrity, and the two embraced with mutual smiles, while Mrs. N. was heard to say in emphatic undertone:

"As we are one again, let there be no more emphasis between us." They thus became Mrs. and Mrs. S. Nicholas without any underlining of either title. And after this amiable adjustment of their misunderstanding, St. Nicholas produced the genuine pack which he had prepared for the family of the Browns, and the distribution of presents gave at last great satisfaction to all concerned.

Published in *Godey's Lady's Book and Magazine,* December, 1879.

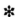

MRS. SANTA CLAUS'S CHRISTMAS EVE

1880: "Mrs. Santa Claus's Christmas Eve", published anonymously.

It was Christmas-eve in Lapland, and Santa Claus was just ready to start. He had put on his fur tippet and cap and ear-lappets, and Mrs. Santa Claus had hidden his soapstone down among the robes, and felt his boots to see if his toes were warm, and lighted his pipe and tucked him in, and now she stood in the doorway, with her spectacles pushed up on top of her head and her cap ribbons flying in the wind, to see him off. "Now, Santa Claus, be sure you don't forget to bring me some flowers, and keep yourself well wrapped up, for you were sneezing this morning, and I'm afraid you've caught cold and don't drive too fast. Remember you've only six reindeer tonight, and you oughtn't to urge them, for you have a real heavy load. Bless me! It gets heavier every year, and I would like some preserved ginger, if you can get it as well as not...."

After watching him out of sight, Mrs. Santa Claus turned around and walked in and shut the door: "As true as preaching he's gone off and forgot the last twelve dollies I dressed! He'll never find it out till he gets to New York, where they are to go, and if he did, he wouldn't turn around and come back...."

She sat down in her rocking-chair and picked up the stocking she was refooting for the dear old saint, and as she rocked and knitted, she wailed and lamented and looked at the dolls, and thought of the twelve little children, and said "Poor dears!" to herself again and again....

Mrs. Santa Claus looked at them all, and rocked and knit and thought till she couldn't stand it. "I'll saddle Blitzen and take them myself," she exclaimed, rolling up her knitting and sticking the needles into the ball. When Mrs. Santa Claus said she'd do a thing she did it. In five minutes, she had an old side-saddle on Blitzen's back, and was dashing down the long, icy slope of Sweden faster than any racehorse could go....

Blitzen rose in the air, and in a moment was on top of a wretched tenement-house. Mrs. Santa Claus hung her basket on the pommel of the saddle, and with the wax doll in her arms stepped briskly across the roof to the chimney. She leaned over and looked down.

What were those things coming up, that vanished as they reached the chimney-top? Some were like tiny pictures, where you saw green fields and trees and winding brooks; some like ugly faces sharply defined on the background of smoke; some like hideous beasts, oftenest a lean and sharp-eyed wolf.

Mrs. Santa Claus drew back. "They are the dreams," she whispered to herself. "I dare not go down there." But as she looked down again there floated slowly up, jostled on every side by the hideous shapes around it, a quaint, forlorn little figure of a doll - a rag doll. One of its arms was gone, and the cotton was coming out of one foot and its dress hung in tatters, and it was very dirty; but its black eyes were shining, and as Mrs. Santa Claus listened, she thought she heard the words, "Dear Santa Claus, please let me have it."

In a moment that little woman had jumped down the chimney. As she passed the Dream she whispered, "Show me!" And the Dream turned and led her into a little room where, in filth and utter wretchedness,

five people lay groaning, tossing uneasily, and muttering broken words of horror in their sleep. Up into one corner, where, on a pile of rags, lay a child, ugly, deformed, dirty, but still a child, asleep-above the tangled, matted head of hair the Dream paused a moment, then floated off. Mrs. Santa Claus laid the lovely wax doll in the child's arms. Then she too went, and the next minute was on the roof again.

"Now, Blitzen," she cried, as she jumped in the saddle and jerked the rein. And they were off once more, never stopping till they reached a large house where a bright light was burning, and a merry laugh floated up the chimney. She listened for a moment and heard, "A girl! if Santa Claus hasn't brought another girl! Ha ha ha! That makes ten girls in this family. I wonder what the old fellow had left for them all." Mrs. Santa Claus laughed till she shook all over, and slipping down the chimney she carefully laid the ten rag dolls out on the hearth in a row, with their feet to the fire. Then she flew up the chimney again. And this time Blitzen took her to an elegant mansion, and, as she listened at the chimney, she heard a child's voice say, "Dear Santa Claus, please bring me something that won't break, and that I can have all the while, and take to bed with me and won't hurt it, and isn't hard and slipper, and won't wear out for ever and ever." And Mrs. Santa Claus took her last doll, the little knit one with the black worsted eyes, and the pink worsted nose and mouth, and the blue turban, and the yellow coat, and laid it down on the pillow beside the child. It woke up just then and stared around a moment, and then, as it saw the doll, it just screamed, "Oh! oh! o-o-o-h!" and hugged it close. And Mrs. Santa Claus?

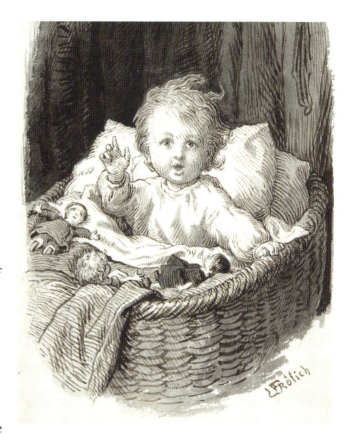

She went up the chimney, and Blitzen took her home, of course. And Santa Claus? When he got home with the ginger and flowers, and his wife told him all about it, he laughed till he cried.

Published in *The Connecticut Churchman* on January 3, 1880.

Credit: *Child In A Crib* by Lorenz Frolich, mid 1800s.

SANTA HAS GOT MARRIED

1880: "Santa Has Got Married", published anonymously.

Once Santa Claus sobered and said with a sigh,
While a tear added luster to each twinkling eye,
"Oh, I'm getting so lonely and weary of life,
I need a companion, or better, a wife;
But where could I find one to share my joy,
And love as I love, every girl and each boy?"
He thot and he pondered, this jolly recluse,
Then he shouted, "I have it; 'tis old Mother Goose."
He was off in a jiffy, he whistled, his sled
O'er the snow like the flight of a skyrocket sped.
And his reindeers snorted, with heads high and haughty,
And trotted along at the rate of two-forty.
So he found the old lady, of course, very soon,
She had just returned from a trip to the moon,
And was fixing her cap, slightly mussed from the ride,
While the cobwebs were thick in the broom by her side.

She was old, she was weazened, she had a great nose,
Yet her eyes were as bright as the plumage of crows,
And her voice tho' 'twas cracked, had a ring very sweet,
And her dress tho 'twas queer, was most awfully neat.
And Santa Claus blushed as he said, "How d'ye do?"
The dame courtesied low, and replied, "Sir, to you."
"Will you have me?" he prays; "my darling, confess."
She hesitates, murmurs, and then whispers, "Yes."
"But my children!" she cries, with the usual pause.
"Why children, I love 'em", said bluff Santa Claus.
"Bring 'em out - where are they? I want 'em", cried he,
So forth trip they all in a great company.
First comes a fair maid and know her we should.
By the wolf and her granny - 'tis Red Riding Hood;
While after them, fearfully blowing his horn,
Is Little Boy Blue on his way from the corn;

And the notes of his music he sweetly doth play
Brings the piper's son, Tom, from the hills far away,
And then with a jump and a roll down the hill,
With pails, and with water, bounce poor Jack and Jill,

As well as a nameless man, tattered and torn,
Who is kissing and kissing a maiden forlorn.
And forth from her garden in a way quite contrary,
With fruits and with flowers, comes sweet Mistress Mary;
Then Simon the Simple returns from the fair,
With the pie-man most cautious in selling his ware;
While dragging their tails behind, flock the sheep
Of the wandering shepherdess, Little Bo Peep.
A very old woman lugs up a great shoe,
And out jump her children, a boisterous crew;
Some sing and some dance, and some of them play
"The Mulberry Bush", and "Rain, Rain Go Away",

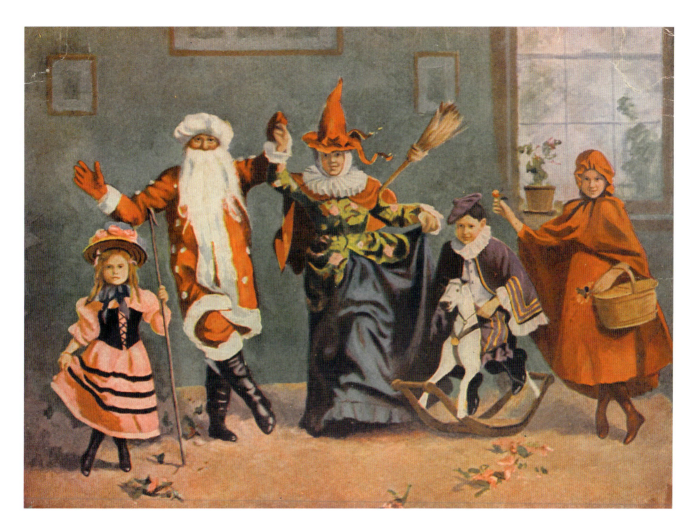

"They are just what I want", shouts old Santa Claus;
Mother Goose and her children ring out their applause.
"Now all jump aboard-our new home we'll explore;
On my sled there has ever been room for one more."
With shouts and with laughter they tumble within,
And wrap buffalo robes close beneath every chin;
The reindeer they galloped, the moon shone out bright
As they hurried along in its soft silver light;
And the fat, jolly driver chuckled often in glee
At the sight of his wife and his vast family.
And the songs of the children rang out on the air
As they journeyed along, disregarding all care,
'Till they reached the great palace and thro' it to roam, And forever be happy within their new home.

Credit: *Santa Has Got Married, The Western Rural*, January 24, 1880.

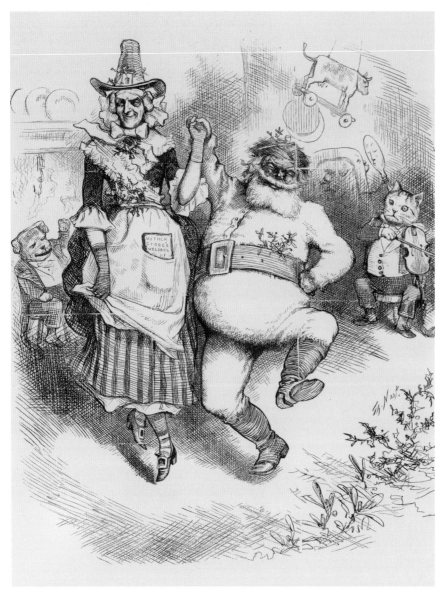

Mother Goose debuted in Charles Perrault's 1695 *Contes de ma Mere L'Oye.* It was translated in English in 1729 and was first published in America in 1786. *Harlequin and Mother Goose,* a pantomime, premiered at Covent Garden Theatre in London, England on December 26, 1806. Attending Mother Goose Christmas pantomimes is an enduring tradition in the UK. Mother Goose and Santa Claus are depicted together in Christmas stories:

1893: *Mother Goose's Ball* by Annie M. Street. Mother Goose dances with Santa Claus and greets children.

1922: *The Boy Who Lived in Pudding Lane* by Sarah Addington. Mother Goose and King Cole help the newlywed Clauses move to the North Pole. Mother Goose is portrayed as Santa's grandmother.

1953: *Santa Visits Mother Goose,* pop-up book. Santa visits with Mother Goose and nursery rhyme characters.

Credit: *A Merry Christmas* by Thomas Nast, 1881.

1881: "A Perfect Christmas" by William O. Stoddard.

A boy runs away from an orphanage and encounters a man he thinks is Santa Claus. He is taken to a home where women are preparing for Christmas. The boy asks: "Are you Santa Claus's wives?"

1882: *The Three Christmas Boxes,* published anonymously:

Now, Santa-Claus, at Christmas time,
Can all the acts of children see:
And as their deeds, are good or ill,
So will their Christmas presents be!
You see him in his easy chair,
His good-wife smiling on him then.

They talk of Tommy's wicked work;
And Santa-Claus with angry frown,
Says, "Wickedness like this, my love,
With punishment, must be put down;
His cruel play shall cost him dear,
No present will he get this year."

Then up, and spoke the buxom dame;
A kind, and feeling heart had she!
"Dear husband, though your judgement blame,
With mercy, let it tempered be;
We'll try his heart with grief and pain,
But lead him back to hope again."

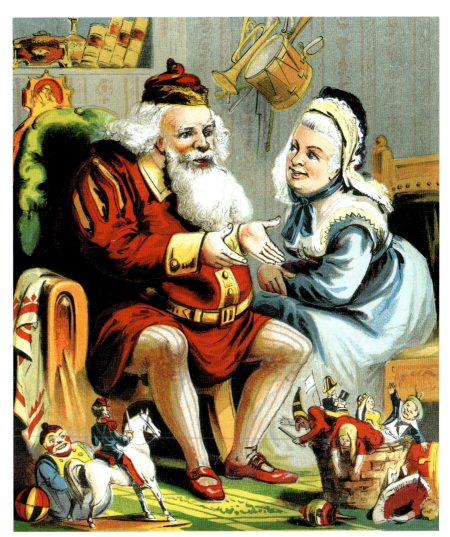

Credit: *The Three Christmas Boxes,* McLoughlin Brothers, 1882.

VISITING SANTA CLAUS

1884: "Visiting Santa Claus" by Lucy Larcom. Two children arrive at the North Pole, and Mrs. Claus asks Santa to return them to their mother. The children wonder if their adventure was a dream. "There's a Mrs. Santa Claus, too; or else I have dreamed about her."

1884: "Mrs. Santa Claus Asserts Herself" by Sarah J. Burke, *Harper's Young People,* January 1.

Excerpt:

Oh, it's all very fine for that husband of mine,
To be courted and praised and invited to dine;
Though late in the day, I'll take while I may
My woman's one privilege of "saying her say."

It's "Santa Claus, dear" – oh, no Santa Claus here"
(Pray pardon this poor little tricklesome tear);
Complimentary strife is the breath of his life,
But who ever mentions his desolate wife?

Now I've nothing to say in a slanderous way
Of the man I have promised to love and obey;
He's a jolly old soul, he acts up to his role,
And as husbands go, he may pass, on the whole.

Oh, I'd never have spoken – my heart might have broken,
I'd have died without leaving one remnant of token –
Did a gossip not say in my hearing one day,
"Santa Claus is a bachelor, tieless and gay."

"You mistake," was my cry, with a flash of the eye;
"I'm his patient and hard-working wife, by-the-bye;
And the world I will stun, when the gamut I run
Of all that I've suffered and all that I've done."

My sufferings first. With a heart nigh to burst,
Each Christmas-eve brings me the sharpest and worst;
When equipped for a start, I see him depart,
While my tremulous hands seek my quivering heart.

"Be careful," I say; "you grow stouter each day"
(We women must smile though our hearts-strings give way);
"Tight-fit chimneys, you know, you must surely forego,
Or be roasted alive by the fire below.

"And darling," I add, "remember the bad
Attack of bronchitis you recently had;
And button your coat high up in your throat,
And don't cross the streams when ice is afloat.

"And keep a tight rein on My Lady Disdain-
Look, dear! she is kicking the dashboard again."
But away he had sped, heeding naught I have said,
While visions of widowhood dance in my head.

Is it nothing, I ask, that my husband should bask
In the popular smile, like a belle at a masque,
While I, poor old crone, sit and cower alone,
Tight clasping the fingers I've worked to the bone?

"With a nod and a blink he would lead you to think
He had dressed all the dolls ere a wensel could wink;
No, while he's in bed – to his shame be it said-
It is I who am plying the needle and thread.

He goes shopping so grand through the length of the land,
But all matters of tastefulness fall to my hand.
Could he crochet and tat, or trim a doll's hat?
Take his clumsy thumb-measure - now answer me that.

Oh, women, whose days are made radiant with praise,
Whose trumpets are blown on the high and by ways,
Pray stifle your scorn for a woman forlorn,
Who is driven to sounding her own little horn.

1885: "Mrs. Kriss Kringle" by Edith M. Thomas,
St. Nicholas Magazine, December.

1885: "Mrs.Santa Claus" written by Grace Melbourne.
Santa asks Mrs. Claus to help deliver presents.

Excerpt:

And so one day he told me:
"You'r such a little mouse,
I hardly dare to ask you
To venture from the house…."

And so, my dear good people
I never stopped a minute,
But ordered up my little sleigh,
And quickly scrambled in it….

Credit: *Santa Claus' Mistake,*
Buels and Co., 1910.

Credit: *What Will Tomorrow Be* by Kate Perugini, 1879.
(Artist, daughter of Catherine and Charles Dickens)

In Santa Claus Land
by Ada Stewart Shelton, 1886.

Of all the busy people
This busy Christmas-tide,
None work like Mrs. Santa Claus,
For days, and nights beside.
The good old Saint, her husband,
Has so much now to do,
If Mrs. Claus did not take hold
He never would get through.
Their home is bright and cheery,
They call it "Reindeer Hall,"
And icicles thatch the roof,
And icebergs form the wall.
The North Star, bright and shining,
Gives all the light they need,
For "How to Climb a Chimney"
Is the only book they read.
They've dolls in every corner,
They've dolls on all the chairs,
Piled high on every cupboard-shelf,
And way up the front stairs.
But not a stitch of clothing
On any can be seen,
Old Santa Claus is nice, but he
Can't sew on a machine.
So Mrs. Claus is working
On petticoats and sacks,
And there are lots of shirts to make
For all the jumping-jacks;
And long clothes for the babies,
And hats and caps and capes,

A HICKORY BACKLOG

Then all the dresses must be cut
In fashionable shapes.
Right on the fire a kettle
Boils, making such a noise!
The lids pop up: how good they smell –
Those lemon-candy toys!
Such stacks of chocolate nice!
The kitchen is a sticky place -
So sticky – but so nice!
The reindeer must be harnessed,
The toys packed in the sleigh;
And Santa Claus wrapped up in furs
To ride so far away.
Then Mrs. Claus he kisses,
And says, "I don't believe,
My dear, that I can get back home
Till nearly New Year's Eve."
And then away he dashes,
While Mrs. Claus does call,
"Be careful how you climb;
I'll worry lest you fall!"
And Santa Claus says, smiling,
"I never in my life
Could do so much for boys and girls
Without so good a wife!"

Published in *The Peninsula Methodist*, Wilmington, DE, December 25.

1887: *A Hickory Backlog*
by Eugene C. Gardner.

Excerpt:

She was dressed for traveling and for cold weather. Her hood was large and round and red, but not smooth, - it was corrugated; that is to say, it consisted of a series of rolls nearly as large as my arm, passing over her head sideways, growing smaller toward the back until they terminated in a big button that was embellished with a knot of green ribbons. Her outer garment was a bright-colored, plaid, worsted cloak, reaching to within about six inches of the floor. Its size was voluminous, but its fashion was extremely simple….

"Being a man," she began, "of course you know nothing abut it, but I assure you it is high time for somebody to interfere. My husband goes around in his jovial style, and if he sees the people eating turkeys, mince pieces, plum puddings and the thousand other things that are absolutely necessary, he doesn't care one straw for the toil and trouble it costs to have them all one to a turn, everything on time and as neat as wax.

If you would do it all by yourselves, or else keep out of the way entirely, it would be a thousand times easier. But when you insist upon building houses to suit your own notions, without knowing the first mortal thing about keeping house, and then expect your wife to take hold and manage them as easily as a mother bird manages the nest she has built, its no wonder we are worn and worried half to death. Now, just to convince you that there is need of reformation, I've got a little list" -

Mrs. Claus, lists the problems encountered by women in household kitchens and offers advise to - "arrange a kitchen that not be a constant trial to the patience of an intelligent housekeeper."

Published in *Good Housekeeping Magazine,* January 22, 1887.

GOODY SANTA CLAUS ON A SLEIGH-RIDE

Credit: *Goody Santa Claus On A Sleigh Ride,* 1889.

1888: "Goody Santa Claus on a Sleigh-Ride" by Katharine Lee Bates.

Santa, must I tease in vain, dear?
Let me go and hold the reindeer,
While you clamber down the chimneys.
Don't give me that sour smirk!
Why should you have all the glory
of the joyous Christmas story,
And poor little Goody Santa Claus
have nothing but the work?

It would be so very cozy,
you and I, all round and rosy,
Looking like two loving snowballs
in our fuzzy Artic furs,
Tucked in warm and snug together,
whisking through the winter weather
Where the tinkle of the sleigh-bells
is the only sound that stirs.

You just sit here and grow chubby
off the goodies in my cubby
From December to December,
till your white beard sweeps your knees;
For you must allow, my Goodman,
that you're but a lazy woodman
And rely on me to foster
all our fruitful Christmas trees.

While your Saintship waxes holy,
year by year, and roly-poly,
Blessed by all the lads and lassies
in the limits of the land. While your toes at
home you're toasting,
then poor Goody must go posting
Out to plant and prune and garner,
where our fir-tree forests stand.

Oh! But when the toil is sorest
how I love our fir-tree forest.
Heart of light and heart of beauty
in the Northland cold and dim,
All with gifts and candles laden
to delight a boy or maiden,
And its dark-green branches
ever murmuring the Christmas hymn.

Yet ask young Jack Frost, our neighbor,
who but Goody has the labor,
Feeding roots with milk and honey
that the bonbons may be sweet!
Who but Goody knows the reason
why the playthings bloom in season
And the ripened toys and trinkets
rattle gaily to her feet!

From the time the dollies budded,
wiry-boned and saw-dust blooded,
With their waxen eyelids winking
when the wind the tree-tops plied,

Have I rested for a minute,
until now your pack has in it
All the bright, abundant harvest
of the merry Christmastide?

Santa, wouldn't it be pleasant
to surprise me with a present?
And this ride behind the reindeer
is the boon your Goody begs;
Think how hard my extra work is,
tending the Thanksgiving turkeys
And our flocks of rainbow chickens –
those that lay the Easter eggs.

Jump in quick then? That's my bonny.
Hey down derry! Nonny nonny!
While I tie your fur cap closer,
I will kiss your ruddy chin.
I'm so pleased I fall to singing,
just as sleigh bells take to ringing!
Are the cloud-spun lap robes ready?
Tirra-lira! Tuck me in.

Off across the starlight Norland,
where no plant adorns the moorland
Save the ruby-berried holly
and the frolic mistletoe!
Oh, but this is Christmas revel!
Off across the frosted level!
Where the reindeers' hoofs strike
sparkles from the crispy, crackling snow!

Now we pass through dusky portals
to the drowsy land of mortals;
Snow-enfolded, silent cities
stretch about us dim and far.
Oh! How sound the world is sleeping,
midnight watch no shepherd keeping,
Though an angel-face shines
gladly down from every golden star.

Here's a roof. I'll hold the reindeer.
I suppose this weathervane, Dear,
Some one set here just on purpose
for our team to fasten to.
There's its gilded cock, the gaby! –
wants to crow and tell the baby
We are come. Be careful, Santa!
Don't get smothered in the flue.

Back so soon? No chimney-swallow
dives but where his mate can follow.
Bend your cold ear, Sweetheart Santa,
down to catch my whisper faint:
Would it be so very shocking
if your Goody filled a stocking
Just for once? Oh, dear! Forgive me.
Frowns do not become a Saint.

I will peep in at the skylights,
where the moon sheds tender twilights
Equally down silken chambers
and down attics bare and bleak.
Let me shower with hailstone candies
these two dreaming boys – the dandies
In their frilled and fluted nighties,
rosy cheek to rosy cheek.

So our sprightly reindeer clamber,
with their fairy sleigh of amber,
On from roof to roof, the woven shades
of night about us drawn.
On from roof to roof we twinkle,
all the silver bells a-tinkle,
Till blooms in yonder blessed East
the rose of Christmas dawn.

Now the pack is fairly rifled,
and poor Santa's well nigh stifled;
Yet you would not let your Goody
fill a single baby sock;
Yes, I know the task takes brains, Dear.
I can only hold the reindeer
And to see me climb down chimney –
it would give your nerves a shock.

Santa, don't pass by that urchin!
Shake the pack and deeply search in
All your pockets. There is always
one toy more. I told you so.
Up again? Why, what's the trouble?
On your eyelash winks the bubble
Mortals call a tear, I fancy.
Holes in stocking, heel and toe?

Goodman, though your speech is crusty
now and then, there's nothing rusty
In your heart. A child's least sorrow
makes your wet eyes glisten, too;
But I'll mend that sock so neatly
it shall hold your gifts completely.
Take the reins and let me show you
what a woman's wit can do.

Puff! I'm up again, my Deary,
flushed a bit and somewhat weary.
With my wedding snow-flake bonnet
worse for many a sooty knock;
But be glad you let me wheedle,
since, an icicle for needle.
Threaded with the last pale moonbeam,
I have darned the laddie's sock.

Then I tucked a paint-box in it
('twas no easy task to win it
from the artist of the Autumn leaves)
and frost-fruits white and sweet,
With toys your pocket misses – oh!
And kisses upon kisses.
To cherish safe from evil paths
the motherless small feet.

Chirrup! Chirrup! There's a patter
of soft footsteps and a clatter.
Of small voices. Speed it, reindeer,
up the sparkling Artic Hill!
Merry Christmas, little people!
Joy-bells ring in every steeple.
And Goody's gladdest of the glad.
I've had my own sweet will.

Published in *Wide Awake Magazine* on December 1, 1888 and in 1889 published as a book by D. Lothrop & Co.

Katherine Lee Bates, born in Falmouth, Massachusetts in 1859, wrote the poem, *American the Beautiful* in 1893.

Credit: *Goody Santa Claus On A Sleigh Ride,* 1889.

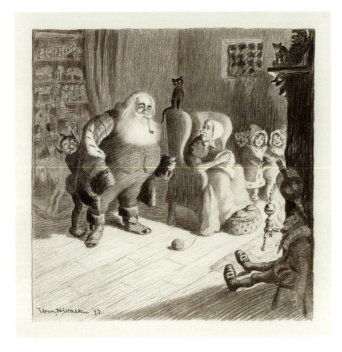 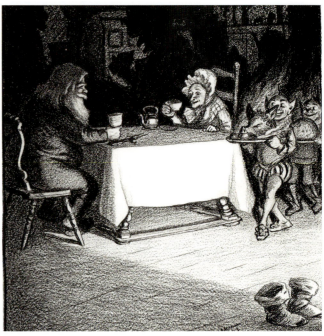

1898: "The Wife of Santa Claus" by Mary A. Cox.

Excerpt:

There was a bustling, crunching of ice, stamping and pawing of feet, then the door bursts open suddenly, as if by a gust of wind, and a nimble little fellow bounces in, all clad in red, flecked with tufts of cotton on cap and shoulders to look like snow. He wears a high, peaked cap of red with a bobbling tassel on the peak, and carries a long thin whip, which he flourishes in time the rhyme he chants…. With a flourish he draws back the curtain, announcing "Mrs. Santa Claus!" There, with a mammoth pumpkin standing by her side, is seen a beaming-faced little fat woman. She is dressed in a fur cloak, or fur-lined circular turned wrong side out, an ermine poke-bonnet, made of white cotton-wool, with black worsted tails, and an immense muff of the same. She steps forward, and in dramatic style delivers:

Mrs. Santa Claus' Address

"Good-evening to you, children dear;
I know you cannot guess
The reason I am here to-night,
And so I'll just confess
That I am Mrs. Santa Claus –

Old Santa Claus' wife;
You've never seen me before,
I'm sure, in all your life.
So if you'll listen patiently,
I'll tell the reason why
Old Santa could not come to-night,
And why instead came I;
He is so very busy now,
Has so many schools – you see
He can't find time to visit all,

And deck each Christmas tree.
And so he said unto his wife:
'My faithful partner dear,
That Sunday-school's expecting me
To help keep Christmas cheer;

As I can't possibly reach there,
I'm disappointed quite:
I know that they will look for me
With shining eyes so bright!'

I, Mrs. Santa, thus replied:
Please let your better-half
Go visit that nice Sunday-school;
'Twill make the children laugh,'
This plan just suited Santa Claus;

He sent Jack Frost to drive;
He knew what fun 'twould be for me
Among you thus to arrive!
And so, lest him you should forget,
That blessed, dear old fellow
The queerest Christmas gift sends you,
This pumpkin, big and yellow;
He hopes that when you cut it up
You'll quite delighted be,
To find the inside quite different

From what you're used to see.
Now if the shell is not too hard
I'll cut it open wide,
That you may see with your own eyes
This curious inside.

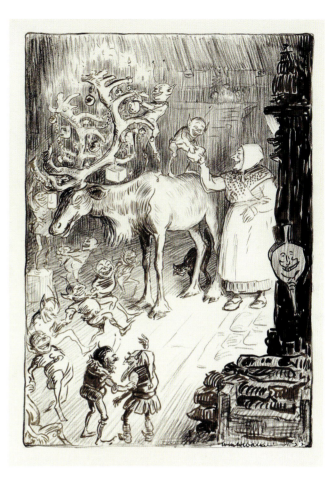

Ah, yes! we've found the inside now,
And present to view
This fairy, who, from Wonderland,
Has come to visit you." ….

The fairy skips out of the pumpkin and sings:
"If you love one another, each sister and brother,
No harm from the fairies you'll fear."

Credit: *Santa Claus with Mrs. Claus* (1897),
Elves Serving Dinner to Santa Claus and Mrs. Claus (1903),
Woman with Group of Elves (1922)
by cartoonist William Henry Walker.

Credit: *Saturday Evening Post* (cover) by Joseph Leyendecker, December 24, 1921.

1902: "Concerning Mrs. Santa Claus" published in *Frank Leslie's Illustrated Weekly* for December 25.

"…should Santa Claus's biography ever be written up, and the whole truth come out concerning his domestic relations, we would not be surprised if it should appear that it was Mrs. Santa Claus who first 'set him up' to the whole reindeer-sleigh, stocking-filling, chimney-descending, joy-bringing trade…."

1910: "A Children's Christmas Prayer" by James W. Foley.

Dear Lord, be good to Santa Claus,
He's been so good to me.
I never told him so because
He is so hard to see.
He must love little children so
To come through snow and storm;
Please care for him when cold winds blow
And keep him nice and warm.

Dear Lord, be good to him and good
To Mary Christmas, too.
I'd like to tell them, if I could,
The things I'm telling you.
They've both been very good to me,
And everywhere they go
They make us glad; - so wonder we
All learn to love them so.

1916: *The Story Lady's Christmas Stories* by Georgene Faulkner, illustrated by Frederick Richardson. Mrs. Claus plans a Christmas party. "Yes," said Father Santa Claus, "it always takes the good mother (Mrs. Claus) to plan and make real Christmas parties."

"We are all children, young and old, at Christmas time. We love to talk and think about Santa Claus and the gifts which he will bring us, and we like to plan how we may play Santa Claus and make someone else happy. Santa Claus embodies this spirit of self-sacrifice and service and so we will enjoy going in our dreams on "A Visit to Santa Claus Land." And what fun we will have when we join with the fairies and dear Mrs. Santa Claus and trim "A Christmas Tree for Santa Claus." … And so may this book of "Christmas Stories," coming right into your home, bring to you a message of Christmas Cheer, with a Merry Christmas to all, From your Story Lady, Georgene Faulkner."

Credit: *Georgene Faulkner,* trade card, 1916.

1916: *Mrs. Santa's Visit to Girl and Boy Land*
by Jennie Burton Walsh.

To my dear little Friends:
You children think of Santa Claus
From August to December;
Perhaps the lines will give you cause
His good wife to remember.
I help him sort the mail each year.
I help to make the toys:
I'd like you all to see me here,
You thoughtless girls and boys.
So don't forget to write to me,
When making your request:
Your true friend then I'll ever be,

And give you my best.
I have just arrived in my Aeroplane
Far from across the Sea;
It would take you several weeks to come,
Though I've made the journey since tea.
You should see our Palace veneered with snow
'Twas built when the ages were new….

In our elegant halls with fire-places bright
We entertain strangers full many a night
The largest and finest factories you see
In Santa Claus Town, belong now to me.

Credit: *Mrs. Santa's Visit to Girl and Boy Land*, Strathmore Press, Toronto, Canada, 1916.

1916: *Miss Santa Claus of the Pullman* by Annie F. Johnston, 1916. Children ride a train and discover the meaning of Christmas.

1918: *When Santa Claus Went to The Front* by Ethel Reed and Martha Kendall.

Scene 1

'Twas the night before Christmas, when in each house,
Every creature is worrying, even the mouse.
No stockings were hung by the chimney with care.
For they knew that St. Nicholas could not be there.
For St. Nick was performing brave deeds of war,
While his wife, do her best, could not travel that far,
Children in kerchiefs and parents in caps
Could no settle down for their long night's nap,
For months Uncle Sam had listened to much chatter,
And now he is trying to solve the matter.

Credit: *Miss Santa Claus of the Pullman*, 1916.

1922: *The Boy Who Lived in Pudding Lane* by Sarah Addington.

In the first in a series of short stories and chapter books written by Sarah Addington involving the Clauses, a young Santa desires to be a gift-giver. He meets and marries Bessie, the Candlestick Maker's niece. The story was reissued by Grafton and Scratch Publishers in 2014.

Sarah Addington graduated from Columbia University, as the only female member of the first class of the Pulitzer School of Journalism.

1922: Mrs. Claus fills in for Santa Claus who is bed-ridden with a broken leg in *The Great Adventure of Mrs. Santa Claus,* written by Sarah Addington. *A Book for Jerry,* of 1925, tells of a young boy who causes problems when he asks Santa for a Christmas book that does not involve girls. In *Tommy Tingle-Tangle,* of 1927, the Clauses deliver toys to fairy children.

Gertrude Kaye, a prominent artist of the Golden Age of American Illustration, illustrated Addington's books.

The Great Adventure of Mrs. Santa Claus.

Excerpt:

"For if they think that it was Santa Claus that came for Christmas, it will be quite the same to them, you know. You see, you are Mrs. Santa Claus; don't forget that." (As if she could ever forget that wonderful fact, thought Mrs. Claus to herself.) Mrs. Claus replies: "Very well," she said aloud. "I'll wear the red suit and stuff myself up with pillows. I really must, I see, for the sake of the children's Christmas." But she told herself that she'd take her skirts along, for she would certainly feel more lady-like if they were near by. And having decided that, she began to have other fears.

"I never drove a reindeer in my life," she spoke up, "much less eight." "They'll go of their own accord," Santa Claus assured her, "knowing the way as they do." "And I never had any occasion to slide down a chimney," she added. "Just step in and down you go, as easy as pie," he told her. "I might leave the wrong things for the right children," she objected further. "Hickety will give you the list," he answered. And so, after all, there was nothing for Mrs. Claus to do except to dress up in Santa's suit, stuff herself with pillows, kiss him good-bye, hop into the sleigh, and drive off on her wonderful errand as Santa Claus's substitute. There was nothing else for her to do, and so she did it, though her little feet trembled in Santa's big boots, her heart flopped wildly under the pillows, and her hand shook as she took up the reins and said "Giddap" in a voice that was only a weak imitation of Santa's big, hearty tones.

Credit: *The Boy Who Lived in Pudding Lane* by Gertrude Kaye, 1922.

Thus, she went off frightened, but courageous, out of the North Country, down into the towns and villages and farmlands, while the children in their beds dreamed of Santa Claus, and Santa Claus in his bed groaned with pain. From roof to roof she went, and down the chimneys, and in every stocking, she left the Christmas gifts that the children had asked Santa Claus for. She even left some that they hadn't asked for, for Santa Claus always has many more toys than his list calls for, you know. Well, on and on she went, and pretty soon she discovered that she was not frightened at all anymore, for playing Santa Claus was really such jolly good fun, and every place she went the children were fast asleep…. But it really all turned out beautifully, after all, due entirely to the enterprise of that astonishing woman, Mrs. Claus.

Published in *Ladies Home Journal Magazine* for December 1922, and published in book form by Little Brown, and Company in 1923.

Credit: *The Great Adventure of Mrs. Santa Claus* by Gertrude Kaye.

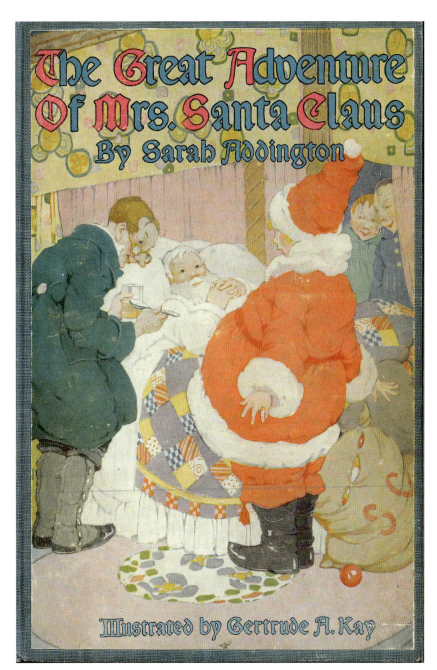

1946: *The Story of Santa Claus and Mrs. Claus* by Alice Holland, illustrated by Lillian Desow. The Clauses live in a red and green house in a land of Christmas trees.

"Mrs. Claus patted the robe around Santa and kissed him on his round chubby cheek. I don't know what I'd do without you, dear," Santa told her.

1950: *The Christmas Forest* by Louise Fatio, illustrated by Roger Duvoison. Santa Claus falls asleep in the forest and the forest animals deliver the presents. A white-haired Mrs. Claus is characterized as a kind, and supportive partner.

"Did you fill my sandwich box?"

"Here it is, with three ham-and-pickle-and-cheese sandwiches. There are also three big slices of Christmas cake, and a bottle of hot coffee. Stop to have a snack after your rounds, not before, dear. You know that you go to sleep after your meal. And don't stay later than you have to. A good fire will be waiting for you," said Mrs. Claus.

1952: *Santa Claus and the Little Lost Kitten* illustrated by Louis W. Myers. Mrs. Claus gives a toy kitten to a child.

1961: "How Mrs. Clause Saves Christmas" by Phyllis McGinley, illustrated by Gyo Fujikawa.

Mrs. Claus is portrayed as a "cozy, rosy, grandmotherly sort, with a twinkle in her eye and a smell of vanilla about her." She wears spectacles, a red stripped blouse, a red skirt and white apron, with a white shawl and cap. Mrs. Claus serves Santa his meals, washes the dishes, sweeps, mends Santa's suit and warms his slippers and dries his boots. She is described as indispensable to Santa with her many great ideas. Santa with a cough on Christmas Eve decides to take a nap. Mrs. Claus seizes the day, pulling on Santa's suit, belted it over a pillow she has stuffed in the pants, adding the boots, cap and gloves and adds a false set of whiskers and grasping a map off she flies on the reindeer-led sleigh. When Santa awakes, he discovers that Mrs. Claus has delivered the gifts. Santa states:

"All right, my dear, we have had it. Once.
But after this leave the Ride to me!"

Credit: P.94

1961:

Jolly Old Santa Claus, stories and paintings by Sparkie George Heinke. Mrs. Claus bakes, keeps a registry of children's names, makes toys, decorates ornaments and plays the piano for the elves.

1967:

"The Season that Santa Forgot He Was He" by Donna Lugg Pape, illustrated by Etienne Delessert. A white-haired Mrs. Claus wears a red dress trimmed in white. Santa bumps his head and is diagnosed with amnesia. A falling star whacks Santa's head restoring his memory and Christmas to be saved.

1968:

The Christmas Santa Almost Missed written and illustrated by Garth Williams. Mrs. Claus with white hair in a bun, wears a blue and white polka dot dress with a white apron. Mrs. Claus has a small role in Santa's visit to "Fantastic".

1985:

Mrs. Claus's Crazy Christmas by Steven Kroll, illustrated by John Wallner. Mrs. Claus delivers a puppy that was forgotten by Santa.

1991:

Santa Claus Doesn't Mop Floors, Bailey School Kids Series by Marcia Jones, and Debbie Dadey. The division of chores and gender roles is explored.

1993:

Mrs. Santa Claus written and illustrated by Penny Ives. Mrs. Claus steps in when Santa and the reindeer get a rash.

2002:

Adventures of the Bailey School Kids Holiday Special: Mrs. Claus Doesn't Climb Telephone Poles by Marcia Thornton Jones. The division of roles explored.

2008:

Mrs. Claus Takes a Vacation written and illustrated by Linas Alsenas. Mrs. Claus misses Santa.

Mrs. Claus Explains It All. Answers to the Questions Real Kids Ask by Elsbeth Claus, illustrated by David Wenzel. Mrs. Claus answers children's questions.

What Does Misses Claus Do? by Kate Wharton and Christian Slade. Mrs. Claus is placed in various Christmas Eve activities.

2012:

Mary Christmas by Gail Mewes. Mrs. Claus and an elf are on a secret mission on Christmas Eve to brings orphan children together with loving families.

2013:

Mrs. Claus. My Life as the Wife of the Big Cheese by Julia Reinfort-Claus. A Mrs. Claus autobiography.

2013 (continued):

The Santa Switch by Laura Lee Scott and illustrated by Cheryl Crouthamel. Mrs. Jessica Claus is the CEO - Chief Elf Optimizer and is the "doer" to her husband the dreamer. In Scott's second book, *A Trip for Mrs. Claus*, Mrs. Claus delivers gifts to those in need.

Christmas Eve with Mrs. Claus by M.P. Hueston, illustrated by Teri Weidner. Mrs. Claus, illustrated as a cartoon white wolf. A lift-the-flap picture book.

2015:

"The Death of Santa Claus" by Charles Harper Webb. Santa Claus suffers a heart attack.

Mrs. Claus's Night Before Christmas by Carrie Mackenzie. Mrs. Claus celebrates with elfish antics and cupcakes on Christmas Eve.

2017:

Holly, The Story of Mrs. Claus by David Rush and David A. Grant. The second book in a series about Santa Claus tells of how he met the future Mrs. Claus.

2018:

Mrs. Claus and the Christmas Stowaway by Carol Anne Carter. Mrs. Claus with a broken ankle may not be able to stop a saboteur of Christmas.

Mrs. Claus Takes the Reins by Sue Fliess. Santa is sick with the flu and Mrs. Claus delivers the presents.

Mrs. Claus Saves Christmas by Yvonne Wonder and illustrated by Brad Sarganis. Santa is sick. Mrs. Claus steps in and thinks Christmas Eve should be a "Claus affair".

I Saw Santa in Michigan by J.D. Green. Mrs. Claus recommends Michigan for a holiday. The edition is part of the regional series with similar books for Alabama, Kentucky, Minnesota, Mississippi, Missouri, New York, and Wisconsin.

2019:

Mrs. Claus and Her Christmas Adventures, Read Aloud Stories for Children by Carol Anne Carter. Mrs. Claus delivers forgotten presents on a snowboard.

How Mrs. Santa Claus Saved Christmas Up and Away with Mrs. Claus by Chloe Gray. Multi-racial elf characters in a story of Santa falling ill and Mrs. Claus stepping in.

2020:

Mrs. Claus Saves The Day by Kharia J. Holmes, illustrated by Mike Motz. Mrs. Claus saves Christmas after Santa breaks his leg snowboarding.

Mrs. Claus Saves Christmas by Christopher M. Benedict, illustrated by Vincent Benedict Jr. Santa is injured, so Mrs. Claus fills in.

Mrs. Claus Saves Christmas by Sharon Ruiz. Santa is injured and Mrs. Claus comes to the rescue.

The Year Mrs. Claus Was Santa by Kathleen Bentley. Santa is ill.

2021:

How Mrs. Claus Saved Christmas by Jerald Pritt, illustrated by Naira T. Tangamyan. A baby reindeer named Ruby helps Mrs. Claus and the elves when the reindeer are sick.

The Truth About Mrs. Claus by Robert Canter. A child asks about Mrs. Claus on seeing an ornament on her teacher's desk of a woman sitting next to Santa.

2022:

The Real Story of Mrs. Claus by Candace Nelson and Kylie Nelson, Mrs. Claus is illustrated as a middle-aged elf character.

The Truth About Mrs. Claus by Meena Harris, illustrated by Keisha Morris. Mrs. Claus wants to do more than bake cookies. She follows her dream to drive the sleigh.

Have You Seen Santa? A Children's Christmas Story by Jamie True. Mrs. Claus and friends search for Santa.

The Night Before Christmas, No It Wasn't Book 3: Mrs. Claus and Her Cold Cup of Tea by Lucy R. Martin. Mrs. Claus is portrayed as a problem solver.

2023:

When Santa Met Mrs. Claus by author and illustrator Brittany Schaeffer. In a forest Santa meets and falls in love with a woman named Sandra.

Black Mrs. Claus Santa Coloring Book, by Melanin Tho.

The Marvelous Mrs. Clause, a rhyming book about gratitude.

Black Santa and CeCe Save Christmas by Baron Davis and Jesse Byrd, illustrated by Shelley Johnson and Laura Moraiti. Cecelia Lee Nicholson is Mrs. C, wife to black Santa.

The Mrs. in Christmas, by Mrs. Heather L. Callaghan, illustrated by Isabel Kent. Mrs. Claus plays a large role in Christmas using love and magic.

Mrs. Claus Does It All, written and illustrated by Amy Dziewiontkoski. A modern Mrs. Claus who travels the world and designs toys.

Mrs. Claus Explains The Meaning of Giving by Dr Dianne Bell. Mrs. Claus teaches the elves lessons inspired by Santa Claus.

Jammie Claus: The Tradition of Unconditional Giving by Megan Holmes and Linda O'Dell, illustrated by Diana Schneider and Madeline Holmes. Mrs. Claus, Jammie Claus, delivers pyjamas on Christmas Eve.

2024:

What Does Mrs. Claus Do for Christmas? by Dr. Evita Oldenburg, and Mark Oldenburg II. A mother explains to her children how hard Mrs. Claus works.

Mrs. Claus's Diaries: Life at the North Pole by Rachel Ogbu. Mrs. Claus works hard, strolls through the Enchanted Forest and talks with reindeer and the Snow Queen.

In the second half of the nineteenth century the character of Mrs. Claus expanded into new genres, including historical novels and romance, murder mysteries, inspiration, self-help, cookbooks and coloring books.

Mrs. Claus' origin story is presented in the following works:

1981: *The Original Story of Santa Claus* by Robert T. Stout. Sarah Heiner, a home economics schoolteacher marries Santa on February 14, 1815.

1982: *The Santa Claus Book* written and illustrated by Alden Perkes. Mrs. Anwyn Santa, an orphaned princess with shining gold hair, escapes from an evil regent. On meeting Santa the couple ride off on a dogsled for their happy-ever-after life. Mrs. Claus tends the elves, and cooks. She is Santa's 'best-kept secret'.

1994: *The Autobiography of Santa Claus* by Jeff Guinn. Santa Claus meets Layla, the future Mrs. Claus, in ancient Constantinople and travel the centuries as husband and wife, interacting in historical events. Guinn's Christmas Chronicle series includes *The Great Santa Claus Search*, and *How Mrs. Claus Saved Christmas*, with Mrs. Claus battling the ban on Christmas in seventeenth century England.

Credit: *Mrs. Claus and the King of France* by Gertrude Kaye, *Ladies Home Journal Magazine,* May, 1923.

2007: *The Story of Mrs. Santa Claus* by Bethanie Tucker, illustrated by Crystal McLaughlin. A young girl named Fauna lives near the North Pole. Fauna meets Santa and introduces him to the flying reindeer.

2009: *The Great Mrs. Claus* by Chris A. Shoemaker illustrated by Cesar de Castro. Santa's senior elf Sparky tells how the Clauses met.

2011: *Annalina: The Untold Story of Mrs. Claus* by Adam Greenwood. Annalina finds herself lost in the snow and is rescued by elves. Years later she is re-united with her friend Nicolia, who has become Santa.

2023: *Mrs. Claus and The Search for Santa* by Russell Ince. Mrs. Claus rescues Santa during WW11.

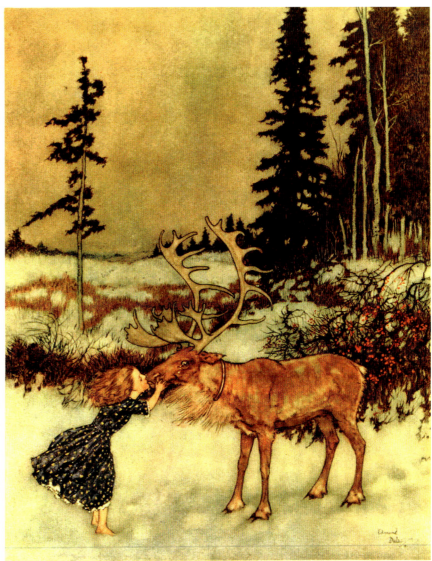

Credit: *Little Girl Holding Flowers* by Joseph Badger, ca.1750-60.
The Snow Queen by Edmund Dulac, 1911.

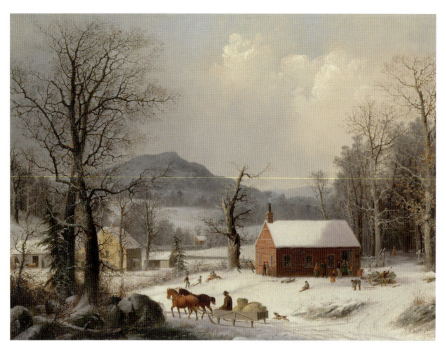

An origin story for the character of Mrs. Claus appears on *YesSantaClausisreal.com* and *NorthPoleCity.com*. The story presents Holly McBride, born at 12:12 a.m. on Christmas Day, 1792. Holly is rescued by Santa after losing her way in the snow. Santa proposes on Christmas Eve, and the pair are married on February 14, 1824. Holly's Irish father and Scottish mother are American immigrants. The Claus' son is named Nick, on whose birth Holly Claus became immortal.

Mrs. Claus' capabilities and abilities include cooking, baking, teaching, sewing, crocheting, singing, playing the piano, dancing, reindeer management, snowboarding, arts and crafts, storytelling, problem solving, keeping lists, piloting a plane and nursing Santa and the elves.

First names applied to Mrs. Claus include Alice, Amelia, Anna, Annette, Annalina, Anwyn, Anya, Bessie, Beth, Carol, Emmy, Fauna, Gertrude, Holly, Jessie, Jessica, Joan, Layla, Lydia, Margaret, Mary, Nancy, Polly, Ruth, Samantha, Sandra, and Sarah. Names by which Mrs. Claus is known include Lady Claus, Lady Christmas, Mrs. North, Mother Claus, Mrs. S. Claus, and Mrs. Santa. Santa Nana and Santa Auntie Claus refer to the sister of Santa Claus.

The Clauses are portrayed in stories as both parents and grandparents. In the 1892 musical *Santa Claus' Daughter,* the Claus' daughter is Kitty. The Clauses have a son named Fritz and a daughter named Bertha in the 1894 play *"The Conquest of Santa Claus"*. *The Legend of Holly Claus* written by Brittney Ryan in 2004 features Holly, the daughter of Santa Claus-King Nicholas and Mrs. Claus. Other names include Noelle and Cassie. The Clauses also have a son with various names, including Nick and Buddy. A reply from AI on the question of the names of the Claus' grandchildren resulted in the suggested names for the Claus grand-children-to-be as Jingle, Peppermint, Noel or Holly.

Credit: *Red School House* by George Henry Durrie, 1858. Vintage postcard.

The state of the Claus' marriage has been the subject of stories, poems, songs, plays and film productions.

2012: *Claus for Divorce? How Santa's wife saved Christmas (and her marriage)* by Jay Heinrichs. With the romance of the Clauses faltering, Mrs. Claus spikes her husband's eggnog and dashes off on the sleigh. Santa, on learning of her solo ride, suggests that next time they go together. Mrs. Alice Claus replies that she would like to steer.

2018: A humorous blogpost - *Claus v. Claus: The Messy Divorce of the Merry Couple* was written for the McFarling Law Group. Excerpt: Santa Claus (hereinafter "Kris," "Santa," "Mr. Claus," "Mr. Kringle") was born in 280 A.D. Before he met Mrs. Claus, Santa was a bachelor and entrepreneur living alone in the North Pole and cruising around in his 1655 convertible sleigh. He founded a start-up toy company in the workshop in his backyard in 1609. The U.S. caught wind of his business in 1773, and his toys gained popularity in 1820 after he discovered he could make more money by making celebrity appearances and posing for photos in shopping malls. That's how he met Ms. Margaret "Mary" Christmas, who was working as a shoemaker in 1830 in New York City. …. Amid some criticism that the immortal pair were rushing things, Santa Claus and Mary Christmas married 29 years later in 1859. The couple gave birth to dozens of beautiful, unusually small, elvish children, who would eventually join the workforce in Santa's workshop. Unfortunately, 160 years later, the couple's marriage soured. Although Nevada is a no-fault state and Mrs. Claus wasn't required to provide a reason for divorcing Santa, she listed plenty in her Complaint. Mary grew tired of Santa's yearly shenanigans, and of trying to take care of a workaholic husband addicted to sweets. After decades of coming second to Old St. Nick's work and having to forego job opportunities other than baking and toy-making, the North Pole began to feel less and less like a postcard and more like a marital prison. Santa expressed little regard for his physical health or the longevity of his life with Mary, and she decided to sue the jolly man for divorce and relocate to sunny Las Vegas…. Mrs. Claus proposes that the reindeer be divided between the parties in alphabetical order… As far as spousal support: Considering a 160-year marriage and the substantial disparity in income, Santa could be looking at a spousal support obligation of around $10 billion per month for about 76 years.

2022: *And What About Mrs. Claus* by Santa Jim. The story tells of the Claus' love and marriage.

2024: *Cooper Finds A Reindeer* by Lori Esclante, Page Publishing. Santa Claus met a kind old woman who becomes Mrs. Claus.

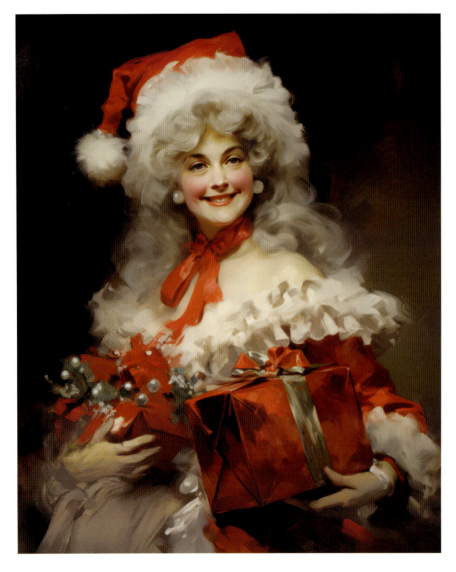

ROMANCE NOVELS

2013: *Calling Mrs. Christmas* by Carol Matthews.

Mrs. Claus: Not the Fairy Tale They Say by Rhonda Parrish.

2017: *Santa Meets Mrs. Claus* by J.L. Hendricks.

2019: *Calling Mrs. Claus* by Charlie Conwell.

2020: *Finding Mrs. Claus* by Leaona Luxx.

The State V. Claus by P. Jo Anne Burgh.

2022: *The Miracle of Mrs. Claus* by O.L. Gregory.

The Perfect Mrs. Claus by Barbara Matteson.

2023: *Becoming Mrs. Claus* by P. Jo Anne Burgh.

Mrs. Claus is Gay by Sabrina Kane.

The Cowboy and Mrs. Claus by Christine Sterling.

Snowed in with Mrs. Claus by Emma Lynn Everly.

The Mrs. Claus Contract by Carol Kinnee.

Save Me, Mrs. Claus by Cheree Alsop.

Mrs. Claus's Wild Night by A.S. Adams.

2024: *Catching Mrs. Claus* by Ava Lynn Wood.

Becoming Mrs.Claus & Stealing Mrs. Claus by Pru Schuyler.

2025: *Mrs. Claus: An Age-Gap, Police Romance* by Lola Gray.

Credit: P.94

MURDER MYSTERIES

Mrs. Claus murder mysteries by Liz Ireland:
2021: *Mrs. Claus and the Hallowe'en Homicide Murder Mystery.*
2022: *Mrs. Claus and the Evil Elves.*
2023: *Mrs. Claus and the Trouble With Turkeys.*
2024: *Mrs. Claus and the Night Before Christmas.*

Mrs. Claus Is A Serial Killer by Fatima Munroe.

Mr. and Mrs. Claus by Linda Mooney.

HUMOR

1990: *Three Days Before Christmas Parody* by John Langdon.

2003: *A Bit of Applause for Mrs. Claus* by Jeannie Schick-Jacobowitz.

2023: *Mrs. Claus Has Menopause* by Bobbie Hiinman, illustrated by Luis Peres.

SPECIALTY TITLES

2012: *Daddy Christmas and Hanukkah Mama* by Selina Alko.

2019: *Mrs Clause and the School for Santa Book* by Timothy Stewart.

Holiday Slay: A Christmas Classic Adult Coloring Book by Latoya Nicole.

INSPIRATION TITLES

2014: *The Secret World of Mr. and Mrs. Santa Claus* by K.C. McKinnon, illustrated by Cecelia Cox.

2023: *Mrs. Claus Explains the Magic of Gratitude* by Dianne Bell.

Mrs. Claus' Closet by Carol and Crawford Mayfield.

2025: *What Would Mrs. Claus Do?* by Pamela McColl and Lindsay Stewart.

COOKBOOKS

2012: *Mrs. Claus's Cookbook* by Mrs. Claus.

2013: *Christmas Eve With Mrs. Claus* by M. P. Hueston, illustrated by Teri Weidner. Lift-the-flap cookbook.

2014: *Mrs. Claus Is an Allergy Friendly Baking Boss* by Monique Faella.

2019: *Mrs. Claus' Christmas Cookies* by Dennis Weaver.

A Very Vegan Christmas, Mrs. Claus' Kitchen by Rebecca Henry.

2023: *Mrs. Claus' Christmas Cookbook* by Christina Tosch.

Color, Sing and Bake with Mrs. Granny Claus and Mrs. Granny Claus and the Christmas Cheer Cookies by Oretha Mobly, illustrated by Remi Bryant.

Mrs. Claus' baking abilities are legendary as is Santa's partiality for her chocolate chip cookies. Leaving milk and cookies out for Santa on Christmas Eve first appeared in the 1870 book *Polly: A Before Christmas Story*. A letter published in *St. Nicholas Magazine* in 1896 references the tradition.

CHAPTER 3 – MUSIC, THEATRE AND FILM

MUSICALS

1854: Mrs. Claus' musical debut was in a production at the New York State Lunatic Asylum, in Utica, NY.

1892: *Santa Claus' Daughter, A Musical Christmas Burlesque* by Elliott Everett takes place at the Claus' North Pole Snow Castle. The Claus' daughter wishes to find a husband.

1894: *The Conquest of Santa Claus* by Caroline Creevy and Margaret Sangster. Elves arrive "from deep green woods" to help Santa deliver Christmas presents.

1914: *Mrs. Santa Claus Militant: A Christmas Comedy* by Bell Elliott Palmer, takes place on Christmas Eve in New York City. 'Mrs. Claus Militant' is described as a large, excitable, red-faced, good-natured woman, who takes Santa's sleigh, gets stuck in a chimney, misplaces the list of gifts, loses the pack of toys, and is distracted by a bargain sale.

1920: *Telephoning to Santa Claus* by John D. Macdonald. Young girls make nuisance phone calls to Mrs. Claus.

A Christmas Dilemma was performed by the National Board of the Young Women's Christian Association in Lancaster, PA., in 1922. The stage directions ask for Mrs. Claus to appear in a red dress with a cape trimmed with cotton to represent ermine, to wear a red bonnet and mittens and to be cast as a jolly little person. The Clauses meet "Old" and "New Year" characters.

1922: *A Strike in Santa Land* – a play in one act by Effa E. Preston. The toys and books at the North Pole do not want to be given away. They have heard terrible stories about how other gifts have been treated. Mrs. Claus tells Santa to be firm with them. Mrs. Claus' costume to be a dark dress, white apron, cap and spectacles.

In Mr. and Mrs. Santa Claus, A musical Christmas play in four scenes by Maud Brunton, Santa Claus marries a Fairy Queen. Distracted by their love for one another they fail to prepare for Christmas, which leads to chaos. The Fairy Queen then marries a Prince and Santa marries Mrs. Claus.

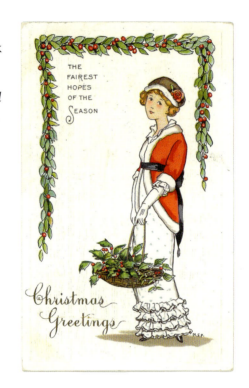

Credit: Vintage postcard.

1924: *Santa Claus' Busy Day, A Play in One Act* by Zoe Hartman. Mrs. Claus is a problem solver at the North Pole.

Santa Claus Behind the Times by Joe Hartman presents Mrs. Claus, along with her daughters, who substitute Santa's sleigh with a magic airplane and submarine. "There's simply no cure for being born behind the times," states Mrs. Claus.

1934: Christmas Spectacular shows, performed by the Rockettes of Radio City Music Hall, New York, NY, have included Mrs. Claus inspired routines over the years.

1939: *Second Marriage of Santa Claus, A Christmas Play in One Act (But Not for Infants)* by John Kirkpatrick, a mixture of realism and fantasy tells of Emmy's elopement with Santa Claus. She is described as a small, somewhat plump little soul of uncertain age, with a pert, round face and wide-open eyes.

2000: *Mrs. Claus. A Holiday Musical* is performed annually by the Chicago Kids Company. Mrs. Claus and the elves search for Santa's missing list.

2016: *Santa Claus – The Musical*, based on the book by Noah Patterson, music and lyrics by David Christensen and Luke Holloway premiered in Fort Worth, Texas. The Clauses retire after 1,000 years.

2019: *Mrs. Claus Saves the Day, A Holiday Musical* written by Christopher Stewart and Lashundra Hood. "The great woman in red" saving Christmas after an outbreak of the North Pole Pox. The musical has been performed by the Cincinnati Children's Theatre, the oldest children's theatre in the USA.

The Ballad of Mrs. Claus, conceived by Dana Merwin and co-created with Lexi Diamond premiered in 2019 at the NewNow in Oakland, CA. Diamond wrote music and lyrics to the show's title song.

2025: *Mrs. Santa Claus,* theatre production music and lyrics by Jerry Herman, based on the book by Alexis Scheer, and on the Halcyon Television Film *Mrs. Santa Claus* by Mark Saltzman, 1996. World Premier Goodspeed Opera House, November 14, 2025. East Haddam, CT.

Credit: *Alice Day,* 1924.

FILM PRODUCTIONS

1897: Santa Claus debuted in the American produced *Santa Claus Filling Stockings.*

1964: Mrs. Claus made her film debut played by Doris Rich in a cameo role in *Santa Claus Conquers the Martians.* Mrs. Claus appeared in a supporting role in Rankin-Bass' stop-motion television special *Rudolph the Red-Nosed Reindeer,* with voiceover by Peg Dixon. An iconic Mrs. Claus, portrayed as a mature and supportive wife to a weary Santa.

1965: In the television holiday special *A Charlie Brown Christmas,* Sally writes to Santa: "How Is Your wife?" Sally writes to Mrs. Claus in *It's Christmastime Again* and remarks on her name of 'Mary'.

1970: *Santa Claus is Coming to Town* features Miss Jessica, a young redhead, who is a schoolteacher who marries Kris Kringle. The voiceover animation by Robie Lester.

The Great Santa Claus Switch, a musical televised special featuring Jim Hensen's Muppets, has a cameo of Mrs. Claus. In the 1990s, Mrs. Claus appeared with Kermit the Frog, Miss Piggy and Big Bird.

1974: *The Miser Brothers Christmas,* the sequel to Santa Claus is Coming to Town. Mrs. Claus takes charge at the North Pole when Santa is injured.

The Year Without a Santa Claus. Mrs. Claus saves Christmas by restoring Santa's spirit. She battles the Snow Miser and other characters with voiceover by Shirley Booth. In 2006, the script was made into a live-action film with Delta Burke playing Mrs. Claus.

Credit: Movie promo poster, 1964.

1979: *Rudolph and Frosty's Christmas in July*. Mrs. Claus and Santa help bring Frosty back to the North Pole. Mrs. Claus' voiceover by Darlene Conley.

1981: *A Chipmunk Christmas,* an animated television special with voiceover for Mrs. Claus by June Foray, the voice of Cindy Lou Who and many other animated characters.

1984: *The Night They Saved Christmas*. Mrs. Claus played by June Lockhart.

1985: *Santa Claus: The Movie.* Mrs. Anya Claus played by Judy Cornwell, helps in the workshop as Santa is overworked.

1990: *Barney and the Backyard Gang: Waiting for Santa*. Mrs. Claus voiceover by Jeanne Cairns. Mrs. Claus connects the gang with Santa on a computer.

1992: *Kidsongs: We Wish You a Merry Christmas*. The kids visit Santa. Mrs. Claus played by Barbara Logan in the music video.

1993: *The Nightmare Before Christmas*. Cameo appearance of Mrs. Claus.

1994: Disney's movie trilogy: *The Santa Clause* 1994, *Santa Clause 2: The Mrs. Clause* (2002), and *Santa Clause 3* (2006) have become classics. Actress Elizabeth Mitchell performed as Carol Newman/Mrs. Claus in the second and third installments of the series. A limited television spin-off series starring the original cast aired in 2022, and 2023.

1996: *The Santa Claus Movie*. The animated television special is an origin story of a character named Nicholas Claus married to Gretchen Claus. They are transported by ship to the North Pole in a miraculous storm.

Mrs. Santa Claus screenplay by Mark Saltzman, music composed by Jerry Herman, produced by Halcyon for television and with Angela Lansbury playing the title role. Mrs. Claus as "Mrs. North" crash-lands the reindeer led sleigh in New York ca. 1910 and is embroiled with a toy maker, in the labor and woman's suffrage movements before returning to the North Pole — where all is well in Claus' merry life.

2000: *The Ultimate Christmas Present* is a Christmas fantasy comedy, with Mrs. Claus played by Susan Ruttan.

2001: *The Family Guy.* Mrs. Claus appears in an episode of the series in 2001 and in 2015 with voiceover of Mrs. Claus by Alex Borstein.

I Saw Mommy Kissing Santa Claus. A young boy takes a picture of his mother kissing Santa and sends it to the North Pole c/o Mrs. Claus, starting a prank-war with Santa.

2004: *Single Santa Seeks Mrs. Claus, Meet the Santas,* Santa's heir must find a wife. Mrs. Claus is played by Marcia Ann Burrs.

2006: Minnie Mouse appeared as Mrs. Claus in the twelfth episode of the first season of *Mickey Saves Christmas,* rescuing Mickey Santa Claus off Mistletoe Mountain. Mickey Mouse dressed as Santa Claus in 1931 in Walt Disney's *Mickey's Orphans*.

2007: *Fred Claus*. Actress Miranda Richardson plays Santa's supportive wife.

2009: *Mrs. Santa Claus Operation Secret Santa*. Actress Betty White plays Mrs. Claus.

2010: *The Search for Santa Paws*. Patrika Darbo plays Mrs. Claus.

FILM PRODUCTIONS (CONTINUED)

2011: *Mistletoe Over Manhattan.* Rebecca Claus, played by actress Tedde Moore, is a nanny for a New York family.

Arthur Christmas. Actress Imelda Staunton provided voiceover for the animated character of Mrs. Claus who is identified in the film as Mother Claus and Margaret.

2012 *Finding Mrs. Claus.* Miro Sorvino playing Mrs. Claus heads to Las Vegas and goes from grandmother to glam in her role as a matchmaker.

Merry In Laws starring actress Shelley Long as "Mamma Claus" interacts with the real world in a disguise. Mrs. Claus is portrayed as loving and cheerful.

2013: *Christmas With Cookie,* comedy/sci-fi. In the future, the North Pole is a desert due to global warming. The Clauses battle aliens and the abominable snowman.

2014: *Northpole.* Santa's city is threatened with a lack of holiday spirit. Actress Jill St. John plays a sweet, grandmotherly Mrs. Claus.

2015: *Becoming Santa.* Meredith Baxter plays a woman named Jessica whose boyfriend must decide if he wants to marry her, as wedding her would make him the next Santa Claus.

2017: *The Untold Story of Mrs. Claus* (Video) by Katie Brown and Anwar Jibawi and Alphacat.

2018: Netflix's *The Christmas Chronicles* and the sequel *The Christmas Chronicles 2,* present Goldie Hawn's Mrs. Claus. She speaks Elfish and is portrayed as a white witch.

2019: *Klaus.* Mrs. Claus, known as Lydia Klaus, appears as a spirit who guides Klaus. She leads him to acts of kindness and as he follows the wind into the light he disappears.

My Adventures with Santa. Actress Barbara Eden plays Mrs. Martha Claus. A family arrive at the North Pole in a magical snow globe.

Santa Girl. The Claus' daughter Cassie sets off for college with her elves, where she struggles between the real world and her impending marriage to the son of Jack Frost.

The Disney film *Noelle* stars Anna Kendrick as the Clauses' daughter Noelle Kringle, Shirley MacLaine as Polly, a Christmas elf and Julie Hagerty as Mrs. Kringle.

2020: *Fatman.* Mrs. Claus, played by Marianne Jean-Baptiste gives advice and wields a gun.

2021: *David and the Elves.* The Clauses travel to the mortal world to save an elf. A health-conscious and fashionable Mrs. Claus is played by Monika Krzywkowska.

2023: *Santa's Second Wife.* After five hundred years Jessica Claus calls their marriage quits. Santa returns to his 40-year-old self in search of love. Mrs. Claus is played by Chelsea Gibson.

2024: *Red One,* Bonnie Hunt portrays Mrs. Claus. Kiernan Shipka is cast as a Christmas witch named Gryla, who captures Santa Claus.

2025: *Mrs. Claus,* starring Jennifer Garner in the title role.

HORROR:

2001: *Grim Adventure of Billy and Nancy.* Mrs. Claus is a vampire in the animated film, with voiceover by Nancy Kane.

2005: *Robot Chicken Christmas Special,* Mrs. Claus turns into a giant monster, with voiceover by Phyllis Diller.

2018: *Mrs. Claus,* college students are stalked by a killer disguised as Mrs. Claus.

In the video game, *In the Service of Mrs. Claus* by Brian Rushton, dark forces have stolen the spirit of Christmas and Mrs. Claus comes to the rescue.

Credit: P.94

SONGS

A survey of songs perused on lyrics.com found 7,561 songs associated with Mrs. Claus, recorded by 206 artists.

1952: "I Saw Mommy Kissing Santa Claus", music and lyrics written by British songwriter Tommie Connor was recorded by American singer Jimmy Boyd, at age thirteen, recorded by The Ronettes in 1963, the Jackson 5 in 1970, and John Cougar Mellencamp in 1987.

1953: "I wish my mom would marry Santa Claus" recorded by Gene Audry.

"Mrs. Santa Claus," recorded by artist Nat King Cole, music and lyrics by Hazel Houle, Jack Fulton, and Lois Steele, was released by Columbia Records. In the lyrics, Mrs. Claus tends reindeer, wraps gifts, packs the sleigh, offers Santa advice, bakes brownies, reads letters from boys and girls, creates the orders for all the toys, sings merrily and fills every heart with wondrous joy. Dean Martin introduces the song with a nod to hardworking Mrs. Claus on "Frank and Dean's Classic Christmas", Vol. 2.

2016: Rachel Porter composed the soundtrack for UK retailer Marks and Spencer's commercial "With Love from Mrs. Claus".

2021: Billie Eilish and Aidy Bryant, both appeared as Mrs. Claus in musical skits on the program *Saturday Night Live*.

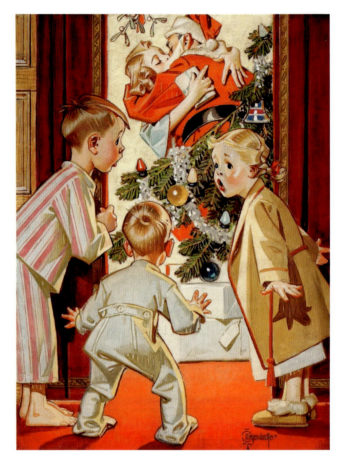

Credit: *I Saw Mother Kissed Santa* by Joseph Leyendecker, 1921.

RECORDING ARTISTS:

Tammy Wynette & George Jones,
"Mr. and Mrs. Santa Claus."

Bon Jovi,
"The Happy Elf."

Katy Perry,
"I wish everyday could be like Christmas."

Garth Brooks,
"The Old Man's Back in Town."

Ariana Grande & Idina Menzel,
"All the Elves and Mrs. Claus."

Kristen Anderson-Lopez,
"A Hand for Mrs. Claus."

Princess Rap,
"Battle of Mrs. Claus and Mary Poppins."

Beauregard Youth Choir,
"Let's Hear It for Mrs. Claus Cool Yule."

Cheech and Chong,
"His Old Lady."

Barbara Logan,
"We Wish You a Merry Christmas."

Duane Johnson,
"Santa's Going to Be Late."

Holly Collins,
"I Can't Wait for Christmas."

Gwen Stefani,
"Santa Claus is the Boss, Cheer for the Elves."

The Oak Ridge Boys,
"Mrs. Santa Claus."

Tiffany Alvord,
"Mrs. Claus."

Lisa Jeanette,
"Mrs. Claus."

Vance Gilbert,
"Mrs. Claus."

These Rhone,
"I think my mommy's Mrs. Claus."

Baja Blink,
"I'm in Love with Mrs. Claus."

Kyle Cox,
"Come on Mrs. Claus, Let me be your Man."

Holiday Roger,
"Let Me Be Your Mrs. Claus Tonight."

Crowder,
"She's Sick of the Beard."

Magdalene Rolka,
"Mrs. Claus."

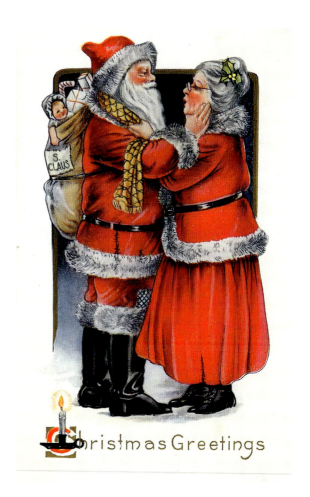

Credit: Vintage postcard.

CHAPTER 4 – MEETING MRS. CLAUS

Dressing as Santa to hand out gifts to children became a popular American tradition in the nineteenth century. Records show prominent Knickerbocker Gulian Verplank, Civil War hero General George Custer, and author Mark Twain participated in the custom.

In 1841, the Philadelphia chef James Wood Parkinson invited children to his delicatessen to meet Santa Claus. Author Jeff Guinn, set his historical fiction series, *The Christmas Chronicles* in the 1841 world of Chef Parkinson along with a disgruntled Santa.

In 1890, James Edgar, the proprietor of Edgar's of Brockton, Massachusetts, appeared in a custom-made Santa Claus suit, launching the first department store Santa.

1899: On December 28th, *The Daily Jeffersonian* of Cambridge, Ohio, reported on Miss Jessie Berkheimer's attendance at a Sunday-school class dressed as Mrs. Claus. After handing out candies and toys Mrs. Claus cracked open a pumpkin out of which jumped a child. It was not reported as being a performance of Mary A. Cox's 1898 play, *The Wife of Santa Claus*. (P. 58-59).

1906: Filenes of Boston, Massachusetts became the first department store to hire a double act Mrs. and Mr. Claus to meet and greet children.

Credit: *Schuler Family Christmas*.
Vintage postcard.

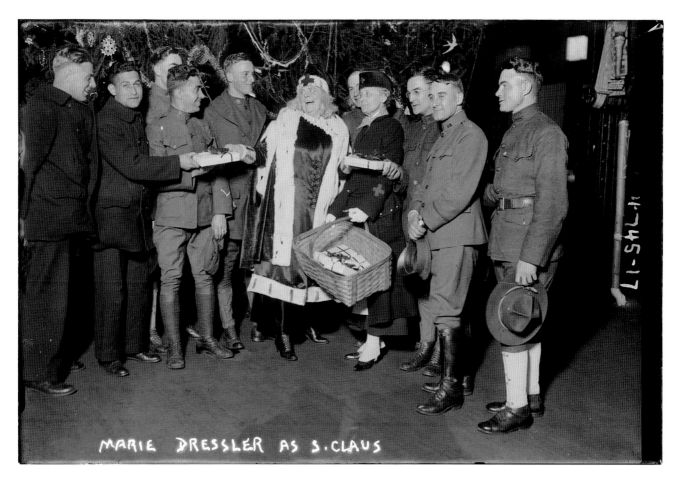

1908: Georgene Faulkner, a teacher, radio personality, and author offered her Mrs. Claus for hire to clubs, private parties, and for Sunday school entertainments in Chicago, IL.

1917: Maria Dressler, an actress of silent and early sound films, brought Claus greetings to US troops posted overseas during WWI.

1920s: Macy's Department Store of New York introduced Santa Lands, a place in the store for children to meet Santa. Santa Lands were copied by stores across America increasing demand for professional Claus performers.

Credit: *Maria Dressler*, Library of Congress, 1917.
R.Mitchell, Photo Studio Berry & Co., Wellington, NZ., 1910.

1937: Charles Howard opened the first professional Claus school in New York City. Two Mrs. Claus presenters were in the school's inaugural class. The media reported that Howard said his Mrs. Claus students were to learn to "greet little girls, learn what they wanted in their stockings, teach them how to play with dollies, doll houses, dishes and clothes." Howard remarked, perhaps in jest: "And she'll have to be good looking."

1942: 'Lady Santa Claus' was coined by makeup artist Max Factor II for female performers who stood in for Santa during WWII. "Kristine Kringle! Sarah St. Nicholas! Susie Santa Claus! Holy Smoke!", wrote a reporter railing against the substitutes.

1943: Saks Fifth Avenue of New York hired British actress Daisy Miller as the store's Mrs. Claus. Miller wore a skirt, jacket, and red stockings, with a gray wig styled in a bun. She assured children that she could grant Christmas wishes.

Frederick and Nelson's of Seattle, Washington, began inviting children to visit their store to have a picture taken with Santa. The idea spread to stores nationwide.

1946: Santa Claus Land opened in Santa Claus, Indiana, as the first such themed amusement park in the world.

1995: A "Lady Santa Claus" of West Virginia was let go as a store's Santa Claus due to her gender. In 1999 a woman from Louisville, Kentucky was similarly fired. Both women lost legal challenges over the firings. In the twenty-first century, women are welcomed as Santa Claus performers. Santa Argyle (Ronda Guile), of San Diego, CA, has visited Santa's Treehouse, a non-profit organization in Jamul, CA, and other locations. "Once I put on the suit; it happened, the moment I looked in the mirror. My heart jumped a beat, and the Spirit of the Season was reborn in a twinkle in my own eyes…I was Santa Claus." – Santa Argyle.

Mrs. Claus presenters take inspiration from various eras of fashion. The Victorian and twentieth century mid-modern styles, as well as Mrs. Claus' grandmother persona are popular, as are female tailored versions of the iconic red suit with white trim. In the 1920s, film studios costumed starlets as Mrs. Claus for publicity photographs. Actresses Alice Day, and Joan Crawford were photographed in short red dresses. Shirley Temple, Bette Davis and Carole Lombard were photographed themed as Miss/Mrs. Claus in the 1930s. In the final scene of the 1954 film *White Christmas* actresses Rosemary Clooney and Vera-Ellen wore Mrs. Claus inspired floor length red ball gowns, trimmed with white fur, with matching hats. Disney World's Mrs. Claus, presented by multi-racial professional performers, wears a red velvet dress with a white apron and is consistently portrayed as an older woman with white hair set under a white cap.

Professional and volunteer Mrs. Claus presenters join in public and private events held over the holidays. Outside of the holiday season Mrs. Claus visits charitable organizations, hospitals, hospices, retirement homes and makes home visits when the need arises. Mrs. Claus officiates at weddings for couples seeking a fairy tale ceremony including at the Viva Las Vegas Wedding Chapel. A Christmas tea with Mrs. Claus is offered at the Wenham Tea House — the oldest operating tea house in America. Mrs. Claus has also shared tea and read stories to generations of visitors to the enchanting Santa's Village at Skyforest, CA. Mrs. Claus is available on podcasts and on various online platforms. In 2021, CBS 8 of San Diego, interviewed Mrs. Claus on their newscast, as other media outlets have done in the past.

Mrs. Claus participates in holiday parades, accompanying Santa Claus or appearing on her own float. Mrs. Claus performed by Eleanor Scannell rode for three decades in the Youngstown, Ohio parade. On her retirement in the 1980s, Scannell passed her Mrs. Claus costume to Jessica Cangiano. Cangiano wore it as the local school bus driver during the holiday season, before giving it to the Mahoning Valley Historical Society. Mrs. O.C. Claus appears with Santa on his "haunted sleigh" in the Anaheim Hallowe'en Parade, sharing the character at a public event beyond the Christmas calendar.

Charles Dennis Troiani author of *Councilwoman Hilda Jefferson, The Mrs. Claus of Charleston* (2014) wrote of Hilda Jefferson: "Whose kindness caused a ripple effect that inspired everyone around her to live better and be better." A testament to Jefferson and her role for decades as a Mrs. Claus presenter.

Credit: *Councilwoman Hilda Jefferson, The Mrs. Claus of Charleston*, 2014.

Performers come to the role of Mrs. Claus from a wide range of professional and personal experiences. From careers in education, childcare, health care and counselling, the armed forces, law enforcement and first responders, business, travel and hospitality, library services, communications and journalism, the culinary arts, fund-raising, fine arts and crafts and as storytellers, musicians, singers, and performance artists.

Claus performer trainings are offered by organizations across the USA. Through educational and networking opportunities, Mrs. Claus performers gain skills that build upon their own talents and abilities. Each with their own special gifts, the performers are unique in the way in which they bring Mrs. Claus to life. All come to the role with the desire to contribute to the wellbeing of others, including their fellow performers in the Christmas community.

Santa Gertrude applies her skills as a teacher to Mrs. Claus. Mrs. Kringle makes spirits bright with her background in the performing arts. Mrs. S. Claus, a retired grief counsellor offers storytelling, and candy making. Mrs. Alice Claus, as a sign language specialist, has brought joy to many a child. Mrs. Santa Claus Finland offers art and gingerbread workshops when children visit her on Hailuoto Island, Finland. Mrs. Katie Claus offers Christmas Eve tuck-ins for children.

Credit: *Mrs. Santa Claus Finland,* Ritva Rundgren.
Mrs. Claus and Spangle, and Spangle Elf, Jessica Rosa, Holiday Photo Magic.

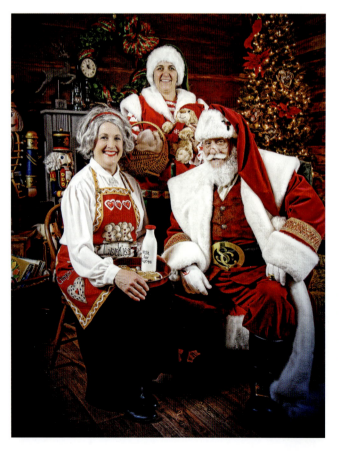

CHAPTER 5 – COLLECTING MRS. CLAUS

Mrs. Claus appears on a wide array of items including Christmas cards, postcards, wrapping paper, stockings, coins, crochet and embroidery kits, dishware, yard figures, puzzles, teddy bears, and on jewellery. Popular brands with Mrs. Claus in their product lines include Annalee, Beanie Baby, Build a Bear, Byers Choice, Danbury Mint, Dept. 56, Fischer Price Little People, Funko, Goebel, Hallmark, The Holly Aisle, Karen Didion, Kurt Adler, Lauscha, Lego, Lladros, Mary Englebreit, Mattel, Murona, Old World Christmas, Radko, Royal Copenhagen, Royal Doulton, Russ Trolls, Steuben, Swarovski, Waterford, and Windy Hill.

Annalee of Meredith, New Hampshire added Santa to their collection in the 1950s, and Mrs. Claus in 1963. Byer's Choice of Chalfont, PA., debuted their first of many Mrs. Claus figurines in 1984. Danbury Mint, of Torrington, CT, produces Mrs. Claus commemorative products, including "cheerleader" figurines, the character with various breeds of dogs, and as a six-piece Mrs. Claus train set. Dept 56, makers of model Christmas villages, produces Mrs. Claus figures, a Mrs. Claus "she shed" and "a milk and cookie stand".

Hallmark produced their first Mrs. Claus Christmas ornament in 1973. It was modelled on the Mrs. Claus of the 1964 televised *The Year Without a Santa Claus.* A fiftieth commemorative edition was issued in 2024. Mattel, since the 1960s, has produced varieties of Mrs. Claus "Holiday Barbie" and "Holiday Hostess" dolls.

Credit: Vintage doll, circa 1930s.
Courtesy of Anita Bearers.

The twentieth century mid-modern era "ceramic kitsch" figures of Mrs. Claus and Mr. Claus salt and pepper set remain popular with collectors. "Ceramic kitsch" was produced by the Japanese brands Napco, Enesco, Lefton and American brands created by Betty Lou Nichols, Betty Cleminson, and Holt-Howard.

Back issues of magazines are a treasure trove of period images and stories from Christmas past. Mrs. Claus has appeared in December magazines over the decades. The cover of *Leslie's Weekly* for December 4, 1913, by Carl Hassmann, and for December 1, 1917, by artist James Montgomery Flagg are editions sought by collectors of Mrs. Claus memorabilia.

The National Christmas Center Family Attraction & Museum in Middletown, PA has an extensive collection of Mrs. Claus items.

Credit: *Jolly Mrs. Santa,* Annalee, 2023. *Dashing Mrs. Claus,* Byer's Choice, 2023.

CONCLUSION: A HEROINE FOR THE AGES

A review of current statistics on the commercials aired on American networks revealed that the number featuring Santa Claus are five-fold to those of Mrs. Claus. The character may be on the verge of catching up with her husband as a series of on-trend mini-movies are generating appreciation for her merry self.

In the 1980s, Shoppers Drug Mart (Canada) hired actress, Bea Arthur to play the role of Mrs. Claus, who sparkled in true "Maud" fashion. In 2016, actress Janet McTeer portrayed an elegant Mrs. Claus, who travels by snowmobile and helicopter in an episode for UK retailer Marks and Spencer. McTeer's Mrs. Claus concludes with a twinkle in her eye: "Well it wouldn't be fun if you knew all my secrets". In 2021, Susan Lucci performed as Mrs. Claus in a mini-movie commercial for Mercedes Benz. Lucci's Mrs. Claus delivers a forgotten present, a puppy for young Sally, by dashing through the snow in a Mercedes Benz G-Class. Actress Adjoa Andoh performed the role in 2024 for the UK retailer Boots' commercial titled "The Christmas Makeover and Making Magic". Andoh remarked on the role: "I wanted her (Mrs. Claus) to be a bit fabulous". The commercial portrayed a bi-racial couple, with black actress Andoh partnered with a white Santa Claus.

Santa Claus was utilized in advertising as early as the 1820s. It would be the Coca-Cola Corporation, who between 1931 and 1964,

turned Santa into a global superstar. Artist Hadden Sundblom's Coca-Cola version of Santa Claus always appeared as jolly, wearing the belted red suit and a wedding ring. Sundblom neglected to depict Santa Claus wearing the ring in one of his images, resulting in Coca-Cola receiving letters from the public asking on the state of the Claus' marriage.

1972: Hadden Sundblom was hired by *Playboy* magazine to render a Mrs. Santa Claus for the December issue. In a painting called *Naughty Santa,* Mrs. Claus wears a red hat and jacket trimmed in fur with "unbuttoned" brass buttons.

Credit: P.94

2003: The organizers of Macy's 2003 annual Thanksgiving Day Parade planned to feature a same-sex couple Mr. and Mrs. Claus. The plan did not materialize.

2018: A Boost Mobile ad, that depicted Mrs. Claus in bed with a snowman, was pulled off the air amidst criticism.

2021: The Norway Postal Service released the commercial *When Harry Met Santa,* to mark the fiftieth anniversary of the decriminalization of homosexuality in Norway.

Health Canada deployed Mrs. Claus in a Covid 19 vaccine and flu shot educational campaign.

CBS Sacramento reported on Mrs. Claus' involvement in a discussion over global warming. A teacher performing as Mrs. Claus told her class: "Santa for a long time has been trying to protect the whole planet by himself, but now he needs everybody's help to do their part." Another news outlet reported that the issue of global warming "was driving Mrs. Claus crazy".

The US Centre of Disease Control enlisted Mrs. Claus to warn about workplace safety: "Santa's Workshop may be magical but, like many workplaces, safety and health hazards can still be present. Fortunately, Santa doesn't need magic to keep his workers safe. To protect elves and promote their well-being, he uses Total Worker Health Approaches. Mrs. Claus also provides ergonomic consultations for any elf or sugar plum maker that wants help at their workstation, and she listens to input from the sleigh-polishers and wreath-makers."

2023: Actress Sheryl Lee Ralph was the first black Mrs. Claus to appear on a float with Santa at the Macy's Thanksgiving Day Parade and wore a white trimmed green coat and hat.

2023: Coca-Cola ran a promotion entitled "The World Needs More Santas." With the aim to emphasis the importance of kindness, generosity and goodwill. Advertisements and contests delivered the message that everyone has an "inner Santa – anyone can be Santa". Coca-Cola launched a mini movie, featuring hundreds of Santas displaying acts of kindness, to their global marketplace.

The world needs more Mr. and Mrs. Clauses and all the kindness, generosity and goodwill the pair exude.

Mrs. Claus is delighted to report that her marriage is rock solid in the twenty-first century. She is pleased with her promotion as CEO of the North Pole but her most satisfying role remains as a keeper of the spirit of Christmas. A role she feels is best deployed without the need for accolades, fanfare or trumpets or a global worldwide publicity tour. A wink and a nod from her partner and dearest husband — the one and only Santa Claus will suffice.

Goodwill to all.

Credit: P.94

CREDITS, CATALOGUE AND COPYRIGHT

P 2: Photograph by Wendy Webb, Wendy Webb Photography

P 4: Vintage postcard: The Miriam and Ira D. Wallach Division of Art, Prints and Photographs: Picture Collection, The New York Public Library. "Christmas greetings." *The New York Public Library Digital Collections.* https://digitalcollections.nypl.org/items/510d47e3-6f8c-a3d9-e040-e00a18064a99

P4: *The Story Lady's Christmas* illustrated by Frederick Richard, 1916.

P 10: *Mrs. Claus* by Metamorphascent for stock.adobe.com

P 20: *Portrait of Mrs. Claus* by Kien for stock.adobe.com

P 57: *Goody Santa Claus on a Sleigh Ride*, illustrator unidentified, photo credit Ekstrom Library, Louisville, KY.

P 66: *Santa Claus and Mrs. Claus in a Sleigh Flying Through the Night Sky* by Tahmina for stock.adobe.com

P 74: *Vintage Style Motif of a Beautiful Smiling Mrs. Claus with Christmas Presents* by Nicola for stock.adobe.com

P 81: *A Cute Mrs. Claus in a Fancy Dress Portrait Christmas Festive Attitude* by Orkidia for stock.adobe.com

P 91: *Modern Mrs. Claus Poses Outdoors* by Studio Iris for stock.adobe.com

P 93: *Mrs. Claus Holding A Christmas Magic Spark in a Her Hands* by Lynn Ann Mitchell for stock.adobe.com

Cover: *The Three Christmas Boxes*, Mcloughlin Brothers, illustrator unidentified, 1882.

Endpapers: *Santa Claus and Mrs. Claus Dancing Together* by Darika for stock.adobe.com

Back cover: *A Radiant Mrs. Claus Skillfully Crafting Toys* by Kien for stock.adobe.com

Library and Archives Canada Cataloguing in Publication
Title: Wondrous Mrs. Claus: a literary and pictorial review of the Christmas character / Pamela McColl.
Names: McColl, Pamela, 1958- author.
Description: Includes bibliographical references and index.
Identifiers: Canadian 20240442490 | ISBN 9781927979389 (hardcover)
Subjects: LCSH: Claus, Mrs. (Fictitious character)—History. | LCSH: Claus, Mrs. (Fictitious character)—Art. | LCSH: Claus, Mrs. (Fictitious character)—In literature. | LCSH: Christmas in popular culture. Classification: LCC GT4992 .M33 2024 | DDC 394.2663—dc2

Wondrous Mrs. Claus

First Edition
Copyright © 2025 Pamela McColl
Printed in South Korea.

ISBN# 9781927979389

Individual copyrights rest with the authors, photographers and illustrators.

All rights reserved. No part of this publication may be used, reproduced, stored, or introduced into a retrieval system, or transmitted in any form, or by any means, without prior written permission of the publisher. Brief passages and poems may be quoted in reviews or scholarly articles.

Grafton and Scratch Publishers

INDEX OF AUTHORS

Authors quoted in this publication:

Sarah Addington, 64
Katherine Lee Bates, 54
Enna Beech, 28
Sarah J. Burke, 50
James Fenimore Cooper, 16
Mary Cox, 58
Charles Dickens, 22
Charles S. Dickinson, 31
Margaret Eytinge, 20
Georgene Faulkner, 5, 61
James W. Foley, 60
Louise Fatio, 66
Eugene C. Gardiner, 53
Georgia Grey, 35
Adam Greenwood, 5
Mrs. W.J. Hays, 15
Alice Holland, 66
M.S. Horton, 42
Lady Jane Hunter, 19
Washington Irving, 15
Caroline H. B. Lang, 19
Kimber Laux, 73
Phyllis McGinley, 66
Clement Clarke Moore, 17
Alice S. Morris, 5

Grace Murray, 26
James Kirke Paulding, 15
James Rees, 24
Margaret E. Sangster, 23
Ada Stewart Shelton, 52
Robert St. Clar, 26
Ethel Reed, 63

Edith M. Thomas, Front
Ellis Towne, 41
Jennie Burton Walsh, 62
Kate Douglas Wiggins, 21

Credit: *A Present Day Saint,*
Life Magazine, December 22, 1910.

AUTHOR'S PAGE

Pamela McColl became interested in the character of Mrs. Claus while working on *Twas The Night – The Art and History of the Classic Christmas Poem.* In delving into centuries of Christmas literature it became apparent to the author that Mrs. Claus' own story was waiting to be told. In 2012, McColl published the first pipe-free edition of *Twas The Night Before Christmas,* capturing widespread attention for the health-conscious edit. McColl presents on the history of Christmas. Contact the author through the website of the publisher: www.twasthenightbook.com.

Much appreciation to the book's editor Margaret Gobie. Thank you to Sung In America and Baker and Taylor Publisher Services, Ashland, Ohio.

Credit: Pamela McColl

Grafton and Scratch Publisher's titles:

Twas The Night: The Art and History of the Classic Christmas Poem by Pamela McColl: ISBN 9781927979303.

Twas The Night Before Christmas. A Bicentennial Edition of the Classic Christmas Poem by Clement C. Moore: ISBN 9781927979341. Board book for babies and toddlers: ISBN 9781927979334. Spanish edition: ISBN 9780987902351.

The Boy Who Lived in Pudding Lane by Sarah Addington: ISBN 9781927979266.

What Would Mrs. Claus Do? Where There is a Wish, There is a Way by Pamela McColl and Lindsay Stewart: ISBN 9781927979419.